Folk Art Journey

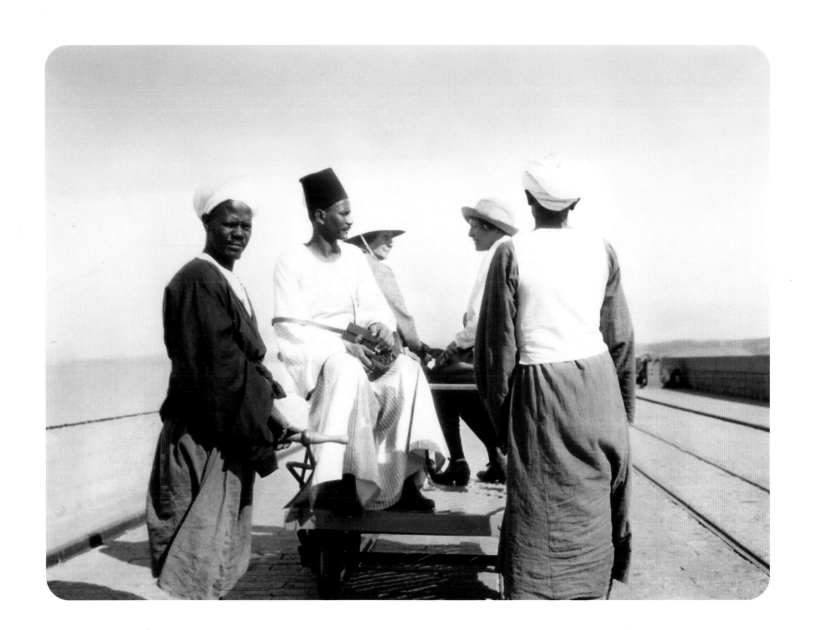

Folk Art Journey

Florence D. Bartlett

and the

Museum

of

International

Folk Art

Featuring the
Florence Dibell Bartlett
Collection

Edited by Laurel Seth *and* Ree Mobley
Principal photography by Blair Clark

Museum of New Mexico Press
Santa Fe

COVER:
Needlework picture
SWEDEN, 1802
(see page 40*)*

FRONTIS:
Florence Bartlett and Maie
Bartlett Heard in Egypt, 1925.
The sisters often traveled the
world together and purchased
items that are now important
collection pieces at the Museum
of International Folk Art.
LANTERN SLIDE COURTESY:
HEARD MUSEUM ARCHIVES,
PHOENIX

This publication was made possible through the generous support
of the International Folk Art Foundation.

All objects reproduced are from the Florence Dibell Bartlett Collection in
the Museum of International Folk Art, Santa Fe, New Mexico, unless otherwise noted.

Abbreviations in the captions refer to these institutions and organizations:
IFAF (International Folk Art Foundation); MNM (Museum of New Mexico);
MOIFA (Museum of International Folk Art).

PROJECT EDITOR: Mary Wachs
DESIGN AND PRODUCTION: Bruce Taylor Hamilton
STUDIO PHOTOGRAPHY: Blair Clark
Manufactured in Korea
10 9 8 7 6 5 4 3 2 1
ISBN 0–89013–442–1 (C); ISBN 0–89013–446–4 (P)

Museum of New Mexico Press
Post Office Box 2087
Santa Fe, New Mexico 87504

Contents

Foreword 7

Acknowledgments 11

Introduction 13
by Laurel Seth

For All the World to See 17
Florence Dibell Bartlett's Vision
for an Untroubled World
by Ree Mobley

The Florence Dibell Bartlett Collection 39

A World Center 95
Founding the Museum of International Folk Art
by Laurel Seth

Bibliography 113

Foreword

Today's visitors to the Museum of International Folk Art arrive at Museum Hill, a complex of museums on Camino Lejo that are linked by Milner Plaza. A beautiful setting with stunning views of the surrounding mountains and foothills of northern New Mexico, the plaza also extends the museum's programming from its interior galleries and spaces to an outdoor area used for performances and workshops.

The museum on Camino Lejo that Florence Dibell Bartlett founded has undergone many changes in the fifty years since its opening. I feel certain that the development of Milner Plaza would have pleased Bartlett because its purpose and uses correlate with her philosophy of experiential learning. Inspired by open-air museums such as Skansen she had visited in Scandinavia, Bartlett visualized a museum environment that would encourage active learning. She wanted a lively atmosphere filled with voices to characterize the museum, not the hushed, reverent attitude of many cultural institutions at that time.

As a witness to two world wars in her lifetime, Florence Bartlett believed that encouraging people to interact with folk art and with one another would help promote cultural understanding. Through art—the result of a universal impulse to create things of beauty—Bartlett hoped that people would recognize the commonalties that cross boundaries. By extension, she saw the museum she established and donated to the people of her

adopted state as a means to foster cultural understanding, where visitors might encounter, appreciate, and learn from the diverse cultures of the world. The vision she articulated for the museum is perhaps as important as the gift of her collection and the building.

The Museum of International Folk Art focuses on the connections of art and people. How we create, use, and modify objects to enrich, protect, beautify, inspire, communicate, warn, amuse, resist, provoke, surprise, decorate, and remember are innately human characteristics. As material culture, folk art speaks to cultural identity—who we are as members of specific groups and communities, religions, and ethnicities—as well as to our occupational and gender identities. Rooted in tradition, it alludes to where we have been, sometimes in homage and sometimes by resistance, but always, if it is authentic, stretching the bounds of possibility. By exploring artistic forms that express shared cultural identity among various peoples, even those whose differences might seem insurmountable or threatening, it is possible to find common ground for communication.

Long before the popular articulation of concepts such as multiculturalism, inclusiveness, and cultural diversity, Bartlett recognized the potential for museums to take an active role in preserving, interpreting, and presenting folk art and by so doing to foster appreciation and acceptance of cultural difference. This is but one example of the visionary thinking behind her goal of creating a museum of international folk art. Further evidence of it is found throughout her plans, for example in her directions to the architect, John Gaw Meem, to locate all public spaces and exhibition galleries on one floor so that the elderly and handicapped might be better accommodated, providing access for them decades before passage of the Americans with Disabilities Act later in the century.

When the Museum of International Folk Art opened officially on September 5, 1953, its exhibition space was 8,000 square feet, an area that has now tripled in size. Initially built to hold approximately 2,500 volumes, the Bartlett Library currently houses well over 15,000. Bartlett's core collection numbered 5,000-plus items and contained textiles, costumes, ceramics, wood carvings, paintings, and jewelry representing the utilitarian objects

of everyday life, as well as those that speak the language of ritual and ceremony. These were the seeds of the present-day collections, now totaling over 130,000 pieces from 100 countries. Her example of generosity has inspired other donors, such as Alexander and Susan Girard and Lloyd Cotsen, to add to the collection. Through the foundation she established, curators and consultants have been able to conduct research abroad and to build the collection through the acquisition of well-documented artifacts in the field.

For fifty years, the Museum of International Folk Art has been documenting, collecting, preserving, and interpreting the creative works of traditional artists from cultures around the world. In keeping with Bartlett's vision, the museum seeks to increase the public's appreciation and understanding of traditional arts, approaching folk art as the artistic expression of shared cultural experiences that are transmitted by members of a community or group. The ongoing and changing nature of communities and their expressive forms can be traced through material culture. The power and significance of folk art derive from its position rooted in the local but interacting with regional, national, and international influences. By presenting folk art and artists within a social context, the museum encourages people to examine process along with finished product, to see the forces of continuity and change, and to begin to explore the complex issues that shape how folk art is perceived both inside and outside a culture.

To maintain the museum's multidisciplinary approach and prepare its interpretive exhibitions, curators and consultants conduct field research around the world to present art in its appropriate cultural and historical contexts. Wherever possible, they work alongside international colleagues to balance curatorial and scholarly perspectives with those of the cultural groups whose art forms are represented. The resultant documentation becomes a valuable part of the collection record and the interpretative framework used for exhibitions and educational programs.

As folk artists must adapt to and incorporate innovation and change in order to survive, so must the museum be flexible in responding to educational needs, preserving the

collections for future generations while providing access to them in the present. Florence Bartlett's linking of the local with the international through folk art envisioned the museum's direction. The term *folk* is not commonly used in the singular; it implies plurality, diversity, and connectedness. At the museum, it conveys collaboration among groups and cultures and affirms the continuing importance of finding connections through the traditional arts. Our need to recognize the common bonds that unite us as humans is no less urgent today than it was half a century ago.

Joyce Ice, Ph.D.
Director, Museum of International Folk Art

Acknowledgments

THIS PROJECT has been a collaborative work, full of challenges and discovery and the realization that there isn't enough time to follow all the threads and write all the books that could connect with this one. I want to thank Susan Mayer and the International Folk Art Foundation Board of Trustees, past and present (especially Dorothy Woolley, Tish Frank, Henry Hoyt, Oliver Seth, Steve McDowell, Teresa Archuleta-Sagel, Darby McQuade, and Willard Lewis), and Joyce Ice and the Museum of International Folk Art staff, past and present, including Yvonne Lange, Charlene Cerny, Judith Chiba Smith, and Nora Fisher, for their support and commitment in carrying on Florence Bartlett's vision. Credit is also due to the fine work of the Museum of New Mexico Press: Mary Wachs, editorial director, and Bruce Taylor Hamilton, designer. My research was much enhanced with the help of Sandra Seth, Sally Hyer, Nancy Hanks, and Peter Bullock, as well as staff at the Chicago Historical Society, the Art Institute of Chicago, and the Eleanor Club; the Museum of New Mexico Photo Archives and the Museum of Fine Arts in Santa Fe; and the Heard Museum in Phoenix. Jean Seth provided memory links to people and places of the recent past as did Nancy Meem Wirth, Marjorie Lambert, Edward T. Hall, James Mayer, and Donald Murphy. I acknowledge my grandfather, J. O. Seth, for his

legal advice to Florence Bartlett in setting up the International Folk Art Foundation and for drafting the legislation for the state to accept her most generous gift. Finally, thanks to my parents, Oliver and Jean Seth, for introducing me to the museum and to the world.

Laurel Seth

Executive Director, International Folk Art Foundation, Santa Fe

Introduction

by Laurel Seth

SANTA FE, once called Po'egae, formally known as La Villa Real de Santa Fe de San Francisco de Assisi and nicknamed "the City Different," has always been unusual compared to other towns of similar size. Even though traveling to New Mexico has typically involved a long journey, those who made that journey and stayed on soon expanded upon the town's cultural and artistic amenities while enriching its involvement in the arts in all its forms. Groups and societies have promoted and preserved cultural expressions from prehistoric times to the modern day. The first printing press in the vast region of the Southwest was in Santa Fe, during the Spanish Colonial period, and the Museum of New Mexico was established by the territorial legislature in 1909, even before New Mexico was a state. So in some ways it was natural that Florence Dibell Bartlett, a wealthy woman from Chicago who had traveled the world and become familiar with the West, would come to love northern New Mexico. She saw it as the perfect place to share her conviction that art, especially folk art, was a universal language, one that if understood and shared through the museum she envisioned could make a difference in how the world's peoples would face the future.

Florence Bartlett was a woman of strong character and considerable influence, who preferred to be called a "civic worker" rather than a philanthropist. Her choice of terms is

fitting because her life's work was devoted to supporting institutions and causes that she believed would make a difference in how people lived and learned. In many ways, her biography resembles that of other women in the social registers of the time. She was born in 1881 into the privileged and dynamic social world of Chicago at the turn of the twentieth century. After graduating from Smith College in 1904, she soon belonged to every important social, civic, and arts club and board in the city. She traveled the world with friends and family and spent summers away from the heat of the city, first at Lake Geneva, Wisconsin, with other Chicago industrialists' families, then later in Nova Scotia. In the 1920s, she came to the place where her story begins to diverge dramatically from her peers in society—New Mexico.

Bartlett spent more than twenty summers in the village of Alcalde, north of Santa Fe, while continuing a parallel life of frequent travels abroad and a lively civic presence in Chicago. She collected folk art from the people she met and the places she visited and also dreamed of eventually creating a showcase for her collection—not just a museum to display objects but an arena for exploration and discussion and ongoing discovery. She saw a place where people would learn about one another in a profound and meaningful way by experiencing folk art. These traditional art forms were important to Bartlett because she witnessed firsthand the changes in society brought by industrialization, commercialization, and other factors that skyrocketed during her lifetime, as clearly as she saw the literal soaring of new buildings each year in Chicago. She believed that the purer, more basic expressions of culture found in handmade and traditional arts and crafts formed a bond from which all peoples of the world could benefit, even in times of great change.

The various objects Bartlett gave or loaned to the Museum of New Mexico from her travels eventually led to serious consideration of establishing a folk art museum. At first, she hoped this could be accomplished by remodeling her ranch, El Mirador, in Alcalde,

but she was soon dissuaded from this idea and saw the practicality of building a new, modern museum in Santa Fe. Negotiations for her gift of the Museum of International Folk Art along with her collection of folk art to the State of New Mexico, the exchange and eventual sale of El Mirador to the state, and the early planning for the museum buildings, programs, and exhibitions took almost five years. In the meantime, Bartlett established a private, nonprofit foundation—the International Folk Art Foundation—to assist the museum, hired its first director, and oversaw each step of the planning and design process. In September 1953, the museum opened its doors officially to an eagerly awaiting public, which has not dwindled in enthusiasm or interest in the ensuing fifty years.

This publication is in honor of the museum's fiftieth anniversary and is a brief overview of those five decades, as well as an introduction to the woman who had the power, vision, and means to establish the museum and define its still relevant purpose.

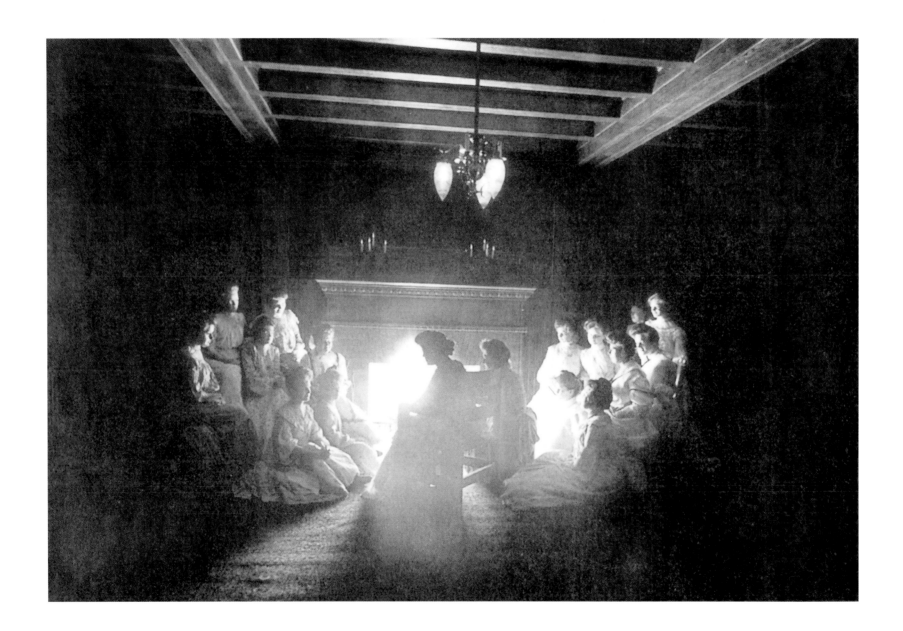

For All the World to See:

Florence Dibell Bartlett's Vision

for an Untroubled World

by Ree Mobley

O
N SATURDAY, September 5, 1953, at 3:00 P.M., the Museum of International Folk Art in Santa Fe, New Mexico, opened its doors to the public. According to the *New Mexican* that day, curious crowds followed hand-lettered directional signs, decorated with the paper-cut motif of a crowing rooster, up the new dirt road off Old Santa Fe Trail to the top of the hill. There, ready for inspection, rested a low, rectangular, earth-colored building, modern in design and surrounded by five mountain ranges, which were canopied that day with banks of low-floating clouds. The name of the new museum had been etched into a horizontal band at the top of the building, and latticed letters above the entrance stated the founder's motto: "The art of the craftsman is a bond between the peoples of the world." The founder's name was conspicuously absent from the inscription and from the name of the museum itself.

For many months, area newspapers had identified the founder as Miss Florence Dibell Bartlett, a wealthy art patroness from Chicago, emphasizing that her gift was the largest single donation ever received by the State of New Mexico and that the museum would be the first of its kind in the world (*New Mexican* 1953). Bartlett was not widely known in the state, and only a few attending the opening reception could claim to know her personally. They included John Gaw Meem, preeminent architect of the Santa Fe Style, who had worked with Bartlett since 1949 on the design and construction of the building; Dr. Robert Bruce Inveriarty, director of the new museum, who at Bartlett's request had traveled throughout the United States and Canada, visiting museums of every

OPPOSITE:

"Fireside Reading" at Haven House, Smith College, 1904. Reading and libraries played an important role in Bartlett's life. At her request, John Gaw Meem included space for a research library in his design for the museum. Bartlett's library of books was a valuable part of her gift to the Museum of International Folk Art.

PHOTOGRAPH BY KATHRYN E. MCCLELLAN. COURTESY: SOPHIA SMITH COLLECTIONS AND COLLEGE ARCHIVES, SMITH COLLEGE

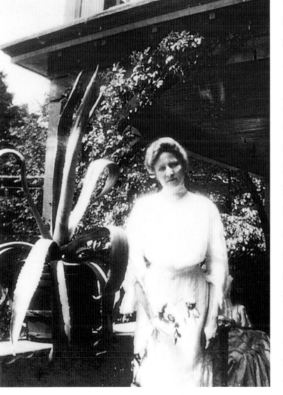

type and size, to ensure that hers would be not only the first but the best of its kind; Dr. Boaz Long, director of the Museum of New Mexico and former U.S. ambassador to Guatemala, whose prompt response to her donation and quick action had been critical in winning approval from the New Mexico legislature to accept her gift; and the artist Gustave Baumann and his wife Jane, who had been Bartlett's friends since the 1920s, when she began her summer sojourns to the San Gabriel Dude Ranch near the village of Alcalde, north of Santa Fe.

Florence Dibell Bartlett followed a simple belief that would eventually lead her to found a singular museum. She believed that the language of art is universal and that in folk art can be found the broadest, most direct expression of that belief. For five decades she traveled the world, seeing and collecting beautiful examples of the art of the craftsman. Her vision, after two world wars and decades of failed efforts to end conflict, reflected a practical woman's path to peace. She sought and eventually found a splendid way to offer an international invitation for people to see the commonality of the human aspiration for beauty and, by seeing, to experience global kinship. In service to her vision for peace and understanding, Florence Bartlett became the founder of the world's first museum of international folk art.

For fifty years, the Museum of International Folk Art has "delighted" (the word visitors most often choose to describe their visit) tens of thousands of visitors each year. Often they arrive not knowing what to expect because the building doesn't look or feel like a traditional museum—all the interior spaces are luminous with vivid colors, and the

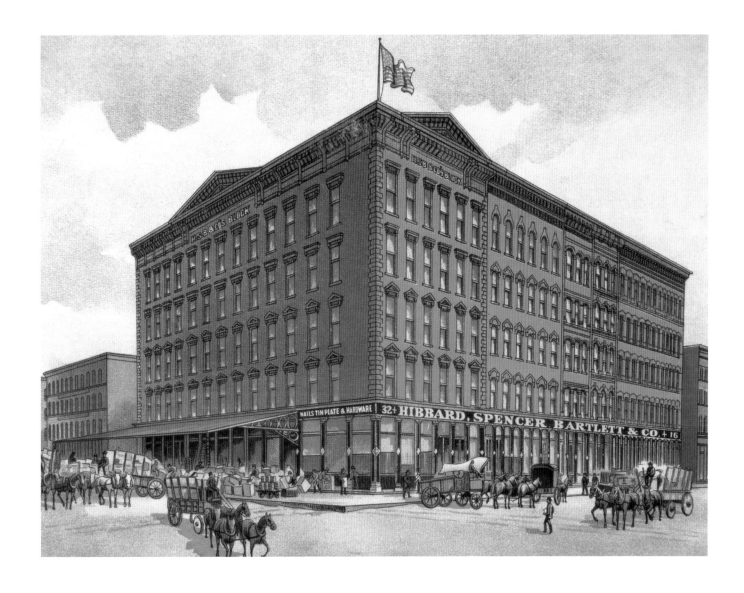

Hibbard, Spencer, Bartlett and Co. salesrooms, 1899, located at 16–32 Lake Street in Chicago. Adolphus Bartlett managed the sales for this successful wholesale hardware company. Eventually, Tru-Value Hardware purchased the firm.

COURTESY: BARTLETT LIBRARY ARCHIVES, MOIFA/MNM

exhibitions are memorable not only for their content but for their design and superb theatricality. Visitors frequently note the whimsical exuberance of this museum that doesn't follow the rules of other museums as it habitually pushes the parameters of the artistic canon by displaying popular arts that reflect the postmodern world, set in real time regardless of shifting political boundaries and virtual ideologies.

THE BARTLETTS OF PRAIRIE AVENUE

Florence Dibell Bartlett was born in Chicago in 1881, the youngest child of Adolphus Clay Bartlett and Mary H. Pitkin Bartlett. Her father was a partner in the firm of Hibbard, Spencer, Bartlett & Co., one of the most successful hardware companies in the country. Adolphus, Mary, and their four children—Maie Pitkin, Frederic Clay, Frank Dickinson, and Florence Dibell—enjoyed a coffered world of wealth and privilege.

The Bartlett home, at 2720 Prairie Avenue, on Chicago's then fashionable South Side, was in a residential enclave of the city's new millionaires, who there sought refuge from the social upheavals of a city whose population doubled every decade between 1860 and 1900. Many of these residents—including such merchants, industrialists, and financiers as Marshall Field, George Pullman, William Armour, John Crear, Cyrus McCormick, Charles Hutchinson, John Glessner, and Henry Gaunsalus—contributed to Chicago's greatest cultural and civic achievements.

After the Great Chicago Fire of 1871, these powerful men worked together in commercial and financial alliances to rebuild the city into one of the richest, most productive, dynamic, and enterprising in the nation. They served as trustees for the Art Institute of Chicago, the Chicago Symphony, and the University of Chicago and were officers in the Commercial Club, the Union League, the Caxton Club, and the Twentieth Century Club. They supported with time, money, and influence efforts to ensure their city would host the World's Columbian Exposition of 1893, because they believed the fair could bring the world to Chicago while bringing Chicago to the world's attention.

Thirty years earlier, in 1863, Adolphus Bartlett had come to Chicago from western New York state. Only nineteen, he advanced rapidly from stock clerk to manager of the sales department and within ten years had become an officer in the company. He was well traveled, setting up offices and sales opportunities for the hardware company, which stimulated his interests in the world outside Chicago. Bartlett was known as a man of great ability, integrity, and modesty who lived by his principles, believing that his time and money should contribute to the public good in direct proportion to his prosperity.

Florence Bartlett seems to have inherited or acquired many of her father's interests and abilities. They shared a love of horses, desire for travel and adventure, understanding of the demands of the marketplace, sense of the importance of understanding people and appreciating their aspirations and achievements, interest in art and literature and adherence to the nondogmatic beliefs of the Unitarian Church, which had opposed slavery, promoted peace, and championed public education. Bartlett also gave his daughter great wealth with its attendant power and responsibility.

Florence Bartlett's brother, Frederic Clay Bartlett (1873–1953), in Chicago in 1907. His 1926 gift of French Impressionist paintings to the Art Institute of Chicago in memory of his wife marked a singular event in the art world. A painter in his own right who graduated from the Munich Royal Academy and studied with Aman-Jean and James McNeil Whistler, he was elected to the American Academy of Arts and Letters at the age of thirty-four. His paintings are in the collections of the Chicago Art Institute, the Corcoran Gallery, and the Carnegie Institute, and his murals remain in public spaces throughout Chicago. COURTESY: THE ART INSTITUTE OF CHICAGO

Florence Bartlett's sister, Maie Bartlett Heard (1868–1951) in 1922 in Phoenix, Arizona. Maie was the eldest daughter of Adolphus and Mary Pitkin Bartlett and married Dwight Heard at the family's Prairie Avenue home in what the Chicago Tribune *described as the society wedding of the season. Founder of the Heard Museum with her husband, she described herself as a "civic worker," a term her sister also preferred.*
COURTESY: ARIZONA STATE HISTORY ARCHIVES, PHOENIX

RIGHT:
The Heard Museum, Phoenix, in 1982. It was one of the first American museums devoted to the art of Native Americans.
PHOTOGRAPH BY SANDRA SETH

Less is known about Mary Pitkin Bartlett. Born in Delavan, Wisconsin, near Lake Geneva, she traveled frequently with her family, and her hospitality was remembered as being equally welcoming to a prince or a peasant. Not enough is known of her, and sparse records confine her to the shadows of her nineteenth-century domestic role. Her early death in 1890 precluded her having a more visible public role, but her children's achievements could be reflections of her interests and values, as well as her husband's. In 1896, Adolphus married Abby L. Hitchcock, and the child of this marriage was Eleanor Collomore.

The Bartlett children made important and lasting contributions to the arts. With her husband Dwight Heard, Maie Bartlett cofounded the Heard Museum in Phoenix. The Heards moved to Arizona after their marriage in 1893, seeking a more healthful climate, and began collecting Indian arts and handicrafts. At first they displayed these objects in their home, Casa Blanca, but in 1929 the Heard Museum opened in an adjacent building.

Frederic Clay Bartlett is remembered for his collection of impressionist paintings given to the Art Institute of Chicago in memory of his wife, Helen Birch Bartlett, who died in 1925. With the gift of the Birch Bartlett Collection, the Art Institute became one of the first American museums to dedicate a room to the impressionists and to exhibit the works of Van Gogh and Gauguin.

Frank Bartlett, the younger son, died in 1900 at the age of twenty, while a student at Harvard University. His friends and teachers described him as a young man of great potential, and his family honored his life by building a gymnasium at the University of

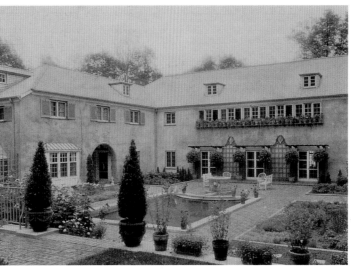

House-in-the-Woods at Lake Geneva, Wisconsin, 1914—the seasonal residence of Adolphus Clay Bartlett. This beautiful summer home set on forty-four landscaped acres was designed by Howard Shaw and Frederic Clay Bartlett. In 1916, Country Life in America *magazine featured the house in an article on "The Best Twelve Country Houses in America." Eleanor Club summer campers enjoyed a yearly invitation to sail the family yacht around the lake.*
COURTESY: THE ART INSTITUTE OF CHICAGO

THE COLUMBIAN EXPOSITION OF 1893: "TO SEE IS TO KNOW"

International fairs and museums have had a long and productive partnership because both have been perceived as having high value for public education. Chicago's World's Columbian Exposition of 1893 was no exception, for following the fair both the Field Columbian Museum and the Museum of Science and Industry were established. Built on Chicago's South Side, not far from Prairie Avenue, the fair ran from May to November, and before its close an estimated twenty-three million people had passed through its gates. Planners, architects, and artists, given license to dream, created the world of the future, the White City—orderly, clean, monumental, and showcasing an American empire of scientific, artistic, and manufacturing excellence. It included a Women's Pavilion and a Bazaar of Nations.

The Women's Pavilion was created to display the art and abilities of women and was managed by the redoubtable Mrs. Potter Palmer, socialite, art collector, and civic leader; she recognized the potential influence and buying power of the "new woman." In 1890s Chicago, the ranks of new women included Palmer, Jane Addams, Judge Mary Barthelme, and Mary Gage. Included in the next generation of exceptional Chicago women would be Florence Dibell Bartlett, Amelia White and her sister Martha, and Alice Corbin Henderson, who made important contributions as cultural leaders in the Southwest.

The fair influenced everyone in Chicago, either directly or indirectly. The *Chicago Tribune* ran a feature story almost every day; of particular interest were drawings and

descriptions of the foreign encampments. For his part, Adolphus Bartlett gave time and money in support of the World's Congress of Religions. He might also have been interested in expanding foreign markets. Hibbard, Spencer, Bartlett & Co. would eventually distribute their hardware goods to Canada, Mexico, South America, Cuba, and the Philippines.

Nineteen-year-old Frederic Clay Bartlett, after seeing the works of impressionists at the fair, concluded that he must go to Europe and become an artist. He did so, graduating from the Royal Academy at Munich and studying in Paris with James McNeill Whistler.

There can only be speculation about Florence Bartlett's visits to the fair and the impact its displays might have had on her. She was still young at the time, but with her family's connections to it and the family home not far from the pier where it was held, it is likely that she visited it a number of times. The popular exhibits representing the architecture and artistic achievements from nations around the globe, the Bazaar of Nations, and the Women's Pavilion might have been of particular interest to her.

The creative energy that the fair generated within the nation may have contributed to the Bartletts' life-long desire to travel and experience other cultures firsthand. In addition, all the issues that would later compel Florence to collect and preserve folk art were evident at the fair and cause for discussion. By 1893, the bleak side of progress resulting from consumerism and mass production was apparent. The loss of traditional handcrafted arts could be observed both abroad and in immigrant communities in the United States. The

potentially destructive schism between labor and producers had become a subject for popular and scholarly debate, and the battle lines for defining ethnology and art were being drawn. Fairs and museums reflected the ironic dilemma of promoters and conservators, who championed the value of traditional popular arts and crafts endangered by the mechanization and consumerism of their own culture. The clear signs that education and sales promotions were becoming blurred grew more evident as objects of desire in the marketplace became object lessons in the museum. Unavoidable questions about gender, public and private space, and national and personal identity had been asked and were waiting for answers (Bronner 1989).

Costume was used to answer some of the questions about identity. The array of exotic clothing exhibited at the fair intensified an existing trend to "trade places" with people of other nationalities, genders, classes, and historical times. The early-twentieth-century passion for pageantry also fit well with the expansion of consumer capitalism, encouraging the notion that identities could be selected, tried on, and acted out to suit the occasion and both individual and collective interests (Mullin 2001: 5; Solnit 1996).

Costume parties, photographs taken in the dress of unfamiliar people from unknown places, and lecturers wearing corresponding national costumes to enhance their presentations became increasingly widespread. Florence Bartlett herself gave travel lectures at the Eleanor Club and the Art Institute of Chicago wearing the costumes of Scandinavia and Palestine. Students at women's colleges

and women in clubs were encouraged to dress as men to experience freedom from gender restrictions and in national costumes to understand various ethnic groups.

Museums, as centers for learning and citadels of culture, offered a popular and powerful response to many of the issues highlighted at the Columbian Exposition. G. Brown Goode of the Smithsonian Institution, invited to classify the exhibits, succinctly summarized the role of museums of the future: "To see is to know."

WOMEN'S CULTURE:
CIVIC WORKERS/CULTURAL LEADERS

At the beginning of the twentieth century, women empowered with wealth began to reject their traditional roles as silent philanthropists who gave their gifts of money and collections with no strings attached. They no longer permitted their gifts to be managed by men on behalf of institutions that often discriminated against women artists, curators, and trustees and that supported a definition of "fine art" in which women's contributions were often excluded. The "new woman" of wealth, power, and education began to recast the artistic canon, to challenge established museum methods, and to pioneer new models (McCarthy 1991: 112). The new woman denied the notion that men created and collected while women decorated.

Florence Bartlett, like other women in her social class, would use the experience and skills she had acquired in the domestic, traditionally feminine sphere to change the definition of cultural leadership. These included household management, with its requisite requirement of proficiency in decorative arts; shopping in the modern department store, which demanded skills of selection and discernment; traveling as an aesthetic experience to acquire knowledge and exercise taste; education at women's colleges, to provide intellectual development and a sense of purpose and to instill confidence through the experience of pageantry, public dramas, and ceremonies; and work in

settlement houses and other philanthropies, which required high degrees of organiza-
tional skill and financial management.

When Florence Bartlett graduated from Smith College in 1904, imbued with a sense
of mission and a confident belief she could positively influence the world outside of
home and family, she joined thousands of other women with active minds who had no
clear-cut work to do and whose social standing did not require them to earn a living.

Guided by the prevailing belief that power and ambition
were inappropriate unless directed to serve society, she,
like her fellow Chicagoan Jane Addams, defined herself
and realized her ambitions and ideals by creating her role
as a civic worker. Her civic work would benefit the Art
Institute, the Renaissance Society of the University of
Chicago, the Boy Scouts, the American Scandinavian
Society, the University Women, and ultimately the
Museum of International Folk Art. She supported first
and foremost the Eleanor Clubs.

THE ELEANOR CLUBS: "SERVICE AND LOVE"

In 1904, Florence Bartlett became associated with the Eleanor Clubs of Chicago, a vast
nondenominational social organization that provided housing, recreation, education, and
employment counseling for working women.

Chicago and other urban centers grew rapidly in the early twentieth century. The
growth of new industries and the expansion of transportation technology created a new
force in the labor pool, the single working woman. Thousands of young women came to
the city to work in department stores and factories, earning from three to seven dollars a

week. The Eleanor Clubs were founded in Chicago in 1898 by Ina Law Robertson to help these women make the transition from rural to urban life, and eventually there were six residences in the city. In many ways, the clubs borrowed from the experiences at women's colleges. Every effort was made to provide inspirational ideals and empowering experiences through reading, recreation, plays, athletic competitions, pageants, and costume parties. These were self-governing clubs, however, not hotels.

Bartlett's work with the Central Eleanor Club in Chicago's Loop and the Eleanor Camp at Lake Geneva, Wisconsin, provided both avocation and vocation. The practical experience she gained would test her philosophy and sharpen her ability to run large operations on a sound fiscal basis. She would also refine her strategies of collecting the art she loved and define her ideas about art education and the aesthetics of learning. Many of the elements that characterized the work of the Eleanor Clubs would later be incorporated in the museum she would found.

Florence Bartlett served as chairman of the Central Eleanor Club for over forty years. During the late nineteenth and early twentieth century, women's clubs often achieved extraordinary goals. In the 1917 annual report for the Central Eleanor Club, Bartlett listed increased membership and attendance at classes and noted that the greatest growth had been in tearoom attendance, where 94,420 homemade meals had been provided. However, once the numbers were analyzed, her comment on the year's real achievements foreshadowed one of the measures for success at her future museum: "Remarkable as is this numerical growth as a practical proof of the usefulness of the club, and splendid as is the growth this year to an actual basis of self-support: yet there is growth of even greater

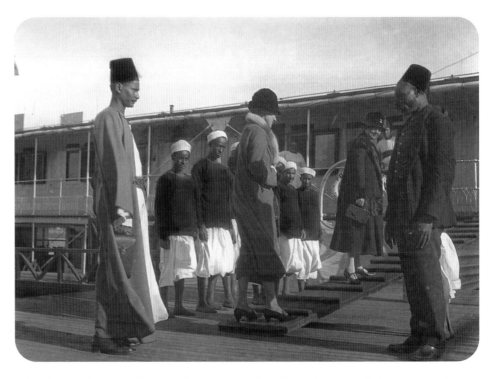

value being achieved—the growth in unity and in the realization of the true significance of the Eleanor watchwords—*Service and Love.*" Continuing, she wrote: "An indication that these watchwords are uppermost in the thought of many club members is the eagerness with which they have seized the opportunities given them by the present World War to render service not only to their own country but to foreign lands" (CECA 1917: 10).

Bartlett rarely missed a meeting, and her annual reports document the travels where she collected the rapidly vanishing folk art she appreciated and wished to preserve. Her reports contain passages that reflect her love of nature and its varied beauty. They usually began with "the scribe of this report," followed by descriptions such as "on an ocean liner sailing from the bold and rugged headlands of Iceland to the North Cape, that wonderful

land of the Midnight Sun [CECA 1929]" or "your scribe nears the glorious, rugged shores of Norway and Sweden [and] has often gazed from her steamer chair across the vast ocean covered at times with a dense almost impenetrable fog, until the sun's warm, piercing rays have dispelled the mists and revealed to view the sparkling, boisterous waves of the sea [CECA 1930]." In another, the scribe is "in the aeroplane at 11,500 feet in the air and sails over the green-clad mountains of Old Mexico, en route to Yucatan . . . a vast sea of white clouds below cover some of the little villages, while glorious snow-capped peaks rise artistically in this early morning light [CECA 1935]."

When Bartlett considered what would be the best gift to the young working women of the Eleanor Club, she chose to help fund an outdoor camp at Lake Geneva, Wisconsin, where they could enjoy themselves freely and renew their spirits in a beautiful place. The Eleanor Club Camp, with grounds, dining room, and accommodations partially financed by her father, gave her joy and contentment throughout her life. Each summer, she traveled to her family's summer home on Lake Geneva and participated in some of the camp's activities. A highpoint of camp season was a trip around the lake aboard the Bartlett yacht.

Although she continued to spend part of each summer at Lake Geneva, by the 1920s New Mexico had become Bartlett's favorite summer retreat.

NEW MEXICO:
EL MIRADOR

New Mexico after World War I offered certain women a new kind of freedom, the freedom to reinvent themselves in a place that was both American and foreign, new and ancient, earthy and mystical. Florence Dibell Bartlett was one of this group of well-traveled women—affluent, usually college educated, and often single. They prided themselves on their good taste and self-conscious distance from the insidious consumerism of

their culture and were confident in their ability to make a difference in their arena of choice. Some, such as Georgia O'Keeffe and Mabel Dodge Luhan, became icons of the new woman in the Southwest. Authors like Mary Austin, Willa Cather, and Alice Corbin Henderson defined the region for readers for many decades. Other women, less well known outside the West and Southwest until recently, include the White sisters, Martha and Amelia Elizabeth; Elizabeth Sergeant; Margretta Stewart Dietrich; and Gertrude Ely. These last five, described as "the Brynmarters," took up the cause of Indian land rights and civil liberties through art with a mantra of "art not ethnography" (Mullin 2001: 90–3).

These women, each in her own way, would redefine women's culture, champion new or neglected art forms, and forge new ways of thinking about art and culture. They came from Chicago, Boston, Lincoln, Nebraska, Carmel, California, and Sun Prairie, Wisconsin, via Paris, Florence, Santiago. They came to visit New Mexico but took up residence in Santa Fe, Alcalde, Abiquiu, Taos, and Tesuque. Two of them built estates along the Rio Grande near the ancient village of Alcalde: Bartlett's El Mirador and Mary Cabot Wheelwright's Los Luceros.

Having a house of their own was important to all of them. Hispanic and Indian influences were evident in the architecture, decorative detail, and handmade objects such as rugs, pots, tinware, woodwork, and blankets. In these pieces made by local craftsmen, an "unalienated expression of identity and individualism," they found an anodyne to the fragmentation of the individual in modern society (Mullin 2001: 51).

El Mirador, "the Outlook," was built on land that had been part of the San Gabriel Dude Ranch, the first place many of the women stayed when they came to New Mexico. At various times, Georgia O'Keeffe, the White sisters, Mary Wheelwright, and Florence Bartlett had visited or been guests of the Richard Pfaffles, who owned and operated the ranch. O'Keeffe commented that "the world is wide here and it's very hard to find it wide

in the east" (Niederman, 1988). And when Mabel Dodge Luhan traveled to Taos, she knew "the dawn of the world" (Rudnick 1984: 143). New Mexico and the Southwest may have seemed less exotic to Bartlett than to the other women because since 1895 she had been visiting her sister Maie Heard in Phoenix. Family photographs from the turn of the century show the Heards and Florence on vacation in Egypt, Arizona, and New Mexico.

Bartlett's house was described in 1950 by the writer John Sinclair, shortly after she had decided that although it would be an unsatisfactory site for her new museum, she would deed the house and property to the State of New Mexico as part of her gift. After his first visit, Sinclair explained his interest: "The historic background [of Alcalde], predating even Santa Fe; the feel of Old World charm; the peace and serenity of Alcalde; the gorgeous landscapes; and, above all, El Mirador, has convinced me that this section of the Rio Grande Valley is 'choice' and people should know about it" (IFAF Records 1950, letter to Boaz Long). Sinclair went on to describe the neighborhood and some of the nearby homes and their owners: Dorothy Kent, sister of the artist Rockwell Kent; Los Luceros, Mary Cabot Wheelwright's home; the dude ranches Rancho Rio and Rancho Embudo; and Swan Lake, the home of Mr. and Mrs. Hamlin Garland. Miss Kent told the writer that "many celebrities spend rest-filled days at El Mirador" and that it was especially favored by the musician Leopold Stokowski (IFAF Records 1950). Bartlett offered hospitality to many guests, and she particularly treasured her guest book with drawings by Gustave Baumann.

Sinclair was given a tour of the seventy-acre property by the estate manager and his wife. He found the Casa Grande and its attendant guesthouses charming and beautifully

appointed, the main house being decorated with murals and woodcarvings by Baumann and Olive Rush. However, it was the grounds that captured his imagination, with the old jail and courthouse for Alcalde dating from the mid-nineteenth century, the four acres of terraced lawns with flower borders and giant shade trees, the cherry trees in blossom, the irrigation ditch with its rock wall, rustic bridges, and occasional waterfalls—all of which he viewed from the lookout tower that gave El Mirador its name.

Sinclair's observations also touched on some of the characteristics of Alcalde that must have contributed to the strong affinity Bartlett and Wheelwright felt for the area. He wrote: "Removed from the fastpaced Santa Fe highway by a mere mile or less, [it] preserves much of the old world Spanish charm and the quiet every day life that goes with it. The whole village is of adobe, cedar picket corrals, primitive brush shelters and outdoor adobe bake ovens—and everywhere the Spanish tongue is spoken by gentle, colorful people" (IFAF Records 1950). He reported taking the metaphysical teacher Manley Hall to Alcalde in 1943. Dr. Hall remarked, "I have seen this village before, although this is my first visit to Alcalde. I have seen it in western China and in north Africa" (IFAF Records 1950). Hall also focused on the extreme contrasts found there. On the evening he visited, he noted the commercial whine of a radio being replaced by the ceremonial "chanting in the village and the shrill piping of a flute" that presaged the passing of a Penitente procession. Outside, the seventeenth century; inside the footwide adobe wall, the twentieth century with its landscaped gardens, electric pumps and appliances, and all the modern conveniences (IFAF Records 1950).

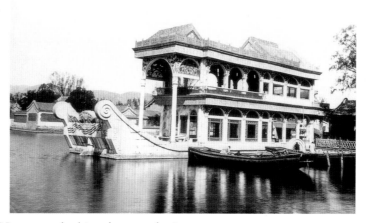

"Chinese Pleasure Palace." The inscription on the photo reads, "Marble boat at Summer Palace. Empress Dowager instead of building a Navy to fight Japan used the money to build the Summer Palace—then had this Marble Pleasure barge constructed—which she called her Navy!"

PHOTOGRAPH ATTRIBUTED TO FLORENCE DIBELL BARTLETT. COURTESY: BARTLETT LIBRARY ARCHIVES, MOIFA/MNM

Although Bartlett customarily used El Mirador only as her summer home, she participated in village life from afar during all seasons, reviewing reports from her estate manager Robert Boyd. Through him she provided a Christmas party with presents for the local children—250 paper bags were filled with oranges, candy, and nuts and distributed (IFAF Records 1949).

The beginning of the 1950s marked significant events in the life of Florence Bartlett: the opening of her museum in Santa Fe, culminating thirty years of collecting folk art from around the world; and the end of five years of planning the design, construction, collections, programs, and financial base for the world's first folk art museum. The early 1950s also saw the deaths of her sister Maie in 1951 and her brother Frederic in 1953, as well as the demolition of the family home on Prairie Avenue in 1950 and dramatic changes in her Chicago neighborhood, where new apartment buildings rose between the once modern buildings of the 1920s and Lake Michigan. In addition, the purpose of the Eleanor Club, which mirrored her youthful idealism and helped create her mature philosophy, had necessarily changed to meet new needs of working women, which no longer included the Eleanor Club Camp at Lake Geneva. Ill health also seemed to shadow her characteristic optimism. Friends in Santa Fe described her as seeming frail at the celebration of Swedish Christmas in 1953 (*New Mexican* 1954).

In May of 1954, Bartlett's life came suddenly to an end when she took her own life. Even though her life's work ended so abruptly, friends in New Mexico and Chicago chose to remember how she had lived, her legacy of love for the world's people, and her practical plan for promoting peace. With the generous faith and hope that was the foundation of the Eleanor Club, club members remembered her generosity and wished her well in

"the adventure of another life" (CECA 1954). And Gustave Baumann, her friend of many years, in response to her sudden death wrote: "The unexpected has intervened, leaving us with many tangled threads, out of which the gentling hand of time will eventually select and weave its own legend" (IFAF Records 1954).

LEGACY

Asked to provide a photograph of herself for the press and other promotions when the museum opened, Florence Bartlett said she would prefer to have a photograph of the museum represent her. When she died, the foundation's board of trustees sent the following telegram to her nephew, Bartlett Heard (IFAF Records 1954):

> The Foundation Board of the Museum of International Folk Art sends you their deepest sympathy at the loss of Miss Florence Dibell Bartlett. She herself hardly realized the widespread appreciation of her generosity not only to the people of New Mexico, but the visitors to the museum from all over the world. She always considered her wealth as a trust to use for others. Her interest was consideration of individuals widespread. Her love of New Mexico has given her a permanent place here so that she will always be remembered.
>
> *Alice G. Howland*
> *Secretary, International Folk Art Foundation*

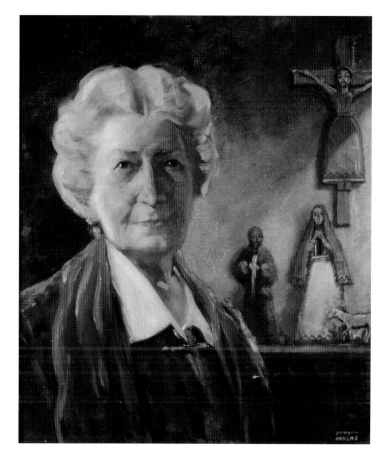

The
Florence Dibell Bartlett
Collection

Portrait of
Florence Dibell Bartlett
NEW MEXICO, 1950s
Irwin Myers
Oil on canvas
IFAF COLLECTIONS, MOIFA

I

Needlework picture
Wilhemina (?)
SKÅNE, SWEDEN, 1802
Silk and gouache on linen
20 3/4 in. × 22 in.
A GIFT OF FLORENCE DIBELL
BARTLETT

ANNIE CARLANO
Curator of European and American Collections

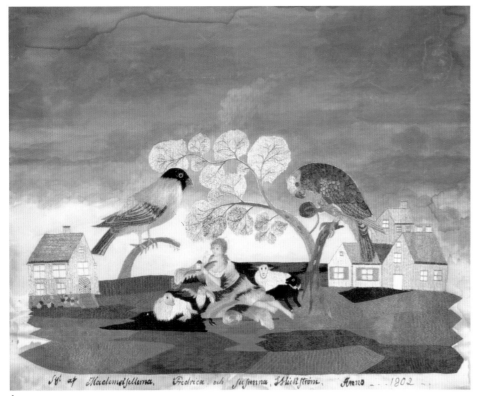

I

I N NINETEENTH-CENTURY northern Europe, part of every upper-middle-class girl's education was embroidery lessons beginning as early as five years of age. From rudimentary alphabets to stitch and pattern samplers, such needlework often reached extraordinary levels of charm and beauty. Accomplished embroiderers went on to create more individualistic needle-work pictures, or "paintings in thread," such as this fine example. The oversized birds and the modernism of the large areas of blocked colors are particularly striking. Embroideries of this quality are rare; it is a masterpiece of the needleworker's art.

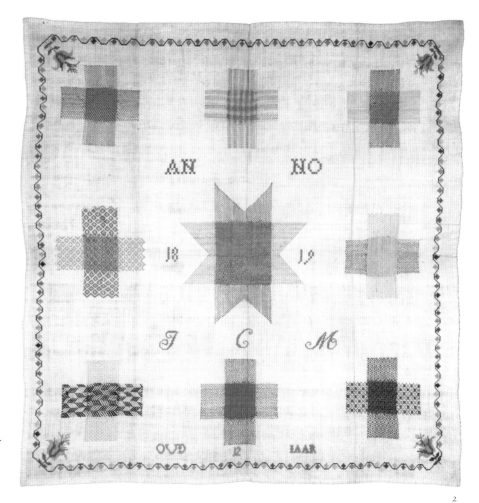

2
Needlework sampler
HAARLEM, THE NETHERLANDS, 1819
Anonymous, "J. C. M."
Silk on linen
31 in. × 30 in.
GIRARD COLLECTION

2

Dutch needlework samplers are unique among all others. They are immediately recognizable by their abstract geometric patterns and by the proliferation of darning stitches. Ignored for centuries as "boring," in recent times they have been prized as masterworks of design. This example displays a soft, pleasing palette, with a central star motif and a sophisticated composition framed by a decorative, running-vine border. It is one of about forty Dutch examples from the Girard Collection. ▨

3
Cookie mold
HUNGARY, C. 1790
Wood

4
Fireplace screen
SPAIN (?), 20TH CENTURY
Wrought iron
(used at El Mirador)

3

4

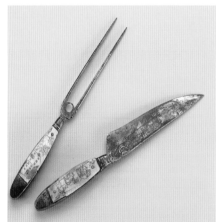

5

Carved wooden case

THE NETHERLANDS, 19TH CENTURY

Wood, iron wire, brass

Such little cases often were used for putting away things for sewing or ornaments.

(Quote from FDB on accession card)

6

Knife and fork with sheath

THE NETHERLANDS, 1786

Steel, bone, leather

Dinner things in leathern sheath. In olden times it was custom that, when people went to pay a visit, they brought with them their own dinner things.

(Quote from FDB on accession card)

7

Knife and fork

THE NETHERLANDS, 18TH CENTURY

Iron, unknown metal, engraved bone

5 7

8
Bride's prayer book
SWEDEN, 1846
Leather, metal, paper

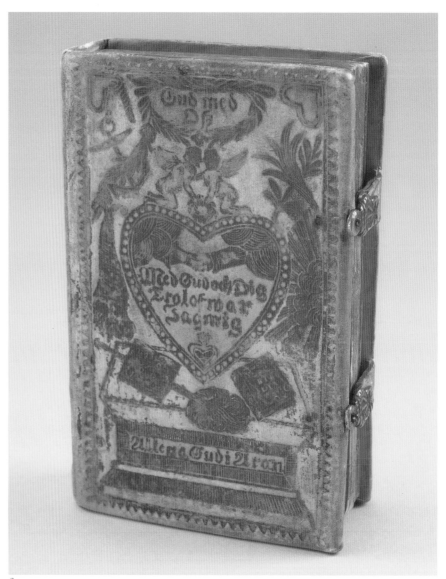

8

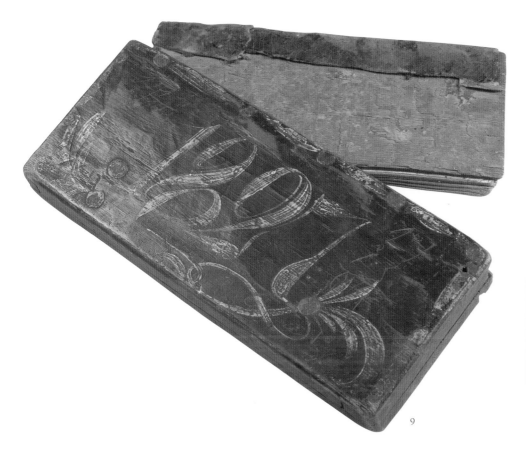

9

9

9
Lutheran catechism
SWEDEN, 1794 (book)/1827 (case)
Wood, leather, paper, ink

10
Three mangling boards
SWEDEN, 19TH CENTURY
Wood

10

11
Wooden canteen, or Kulacs
HUNGARY, 20TH CENTURY
Wood, leather, metal, paint
GIFT OF MAIE BARTLETT HEARD,
THE HEARD FOUNDATION

12
Glass bottle
with painting
(front and obverse)
U.S.A., 1880–1894
Made by Andrew Clemens,
McGregor, Iowa
Glass and sand from
Pictured Rocks, Iowa

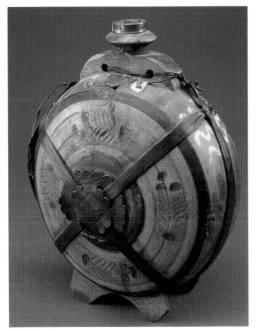

11

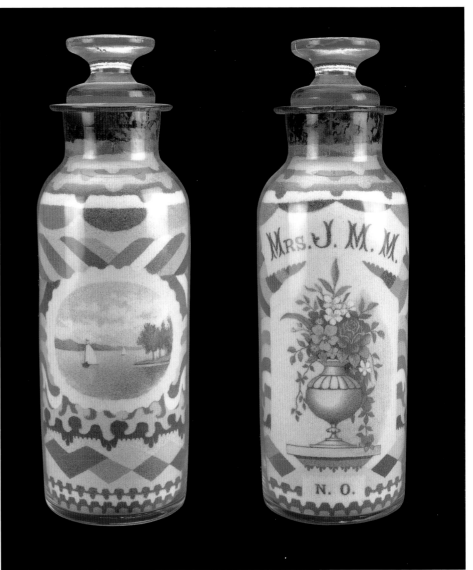

12

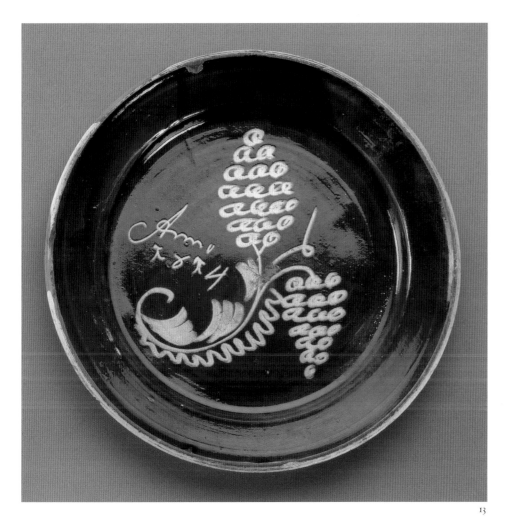

13

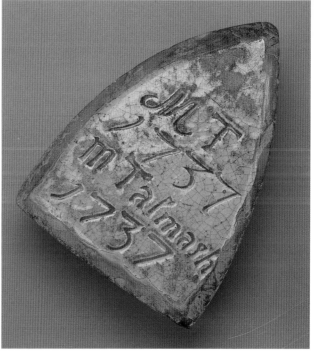

13
Ceramic plate
HUNGARY, 1824
Glazed earthenware

14
Flatiron stand
ENGLAND, 1737
Glazed earthenware

15
**Money box with
hens and chicks**
ENGLAND, C. 1790
Glazed earthenware

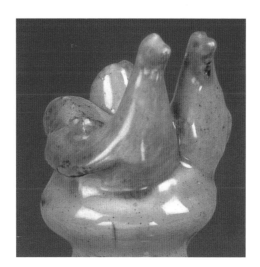

15

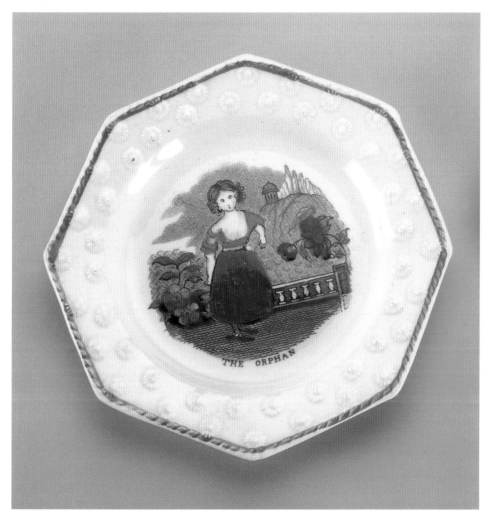

Two ceramic plates,
"The Orphan" and
"My Brother"
EARLY AMERICAN, 19TH CENTURY
Ceramic, paint

16

49

¹⁷
Egg stand
ENGLAND, C. 1700
Glazed earthenware

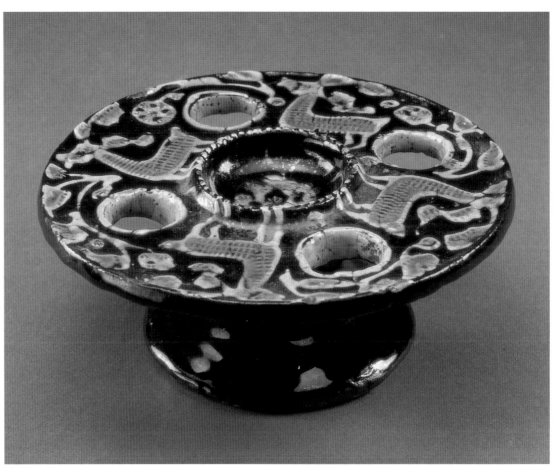

17

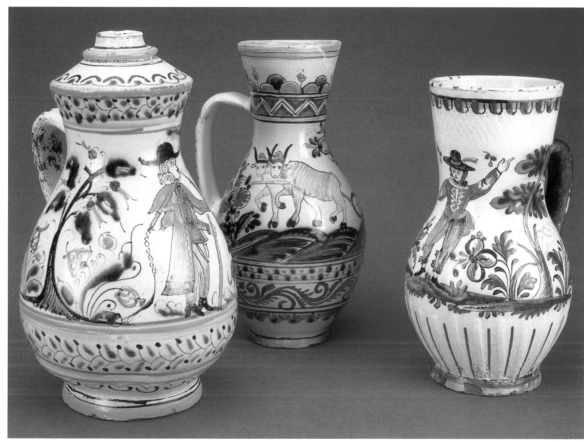

18

18
Three pitchers
HUNGARY, N.D.
Clay

19
Pitcher
EUROPE, N.D.
Glazed earthenware
GIFT OF MAIE BARTLETT HEARD,
THE HEARD FOUNDATION

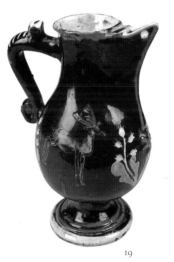

19

Ceramic bottle
(two views)
HUNGARY, MAY 8, 1875
Glazed earthenware

20

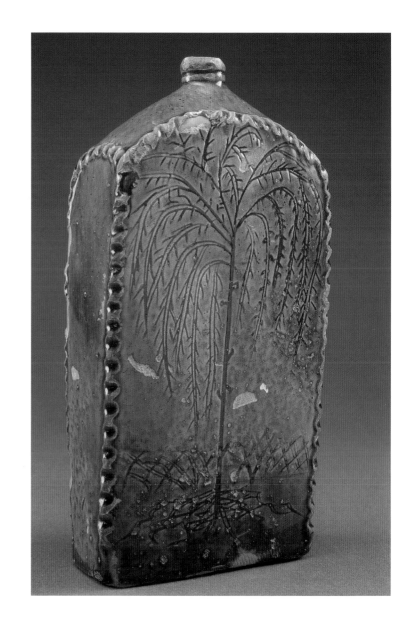

Ink stand
HUNGARY, 1820
Glazed earthenware

21

22
French cloth
FRANCE, 18TH CENTURY
Printed cotton

23
Greek textile
RHODES, GREEK ISLES,
EARLY 20TH CENTURY
Linen, silk

22

23

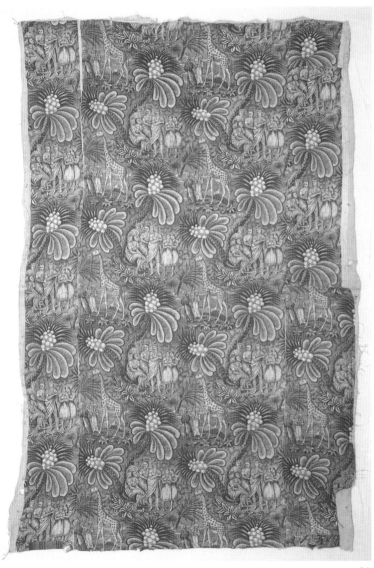

24
French cloth
FRANCE, C. 1785
Printed cotton

25
Plate
EUROPE, N.D.
Porcelain, paint

26
Swedish wedding box
SWEDEN, 1976
Wood, paint

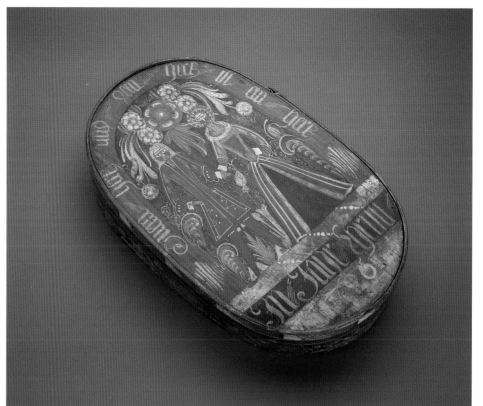

26

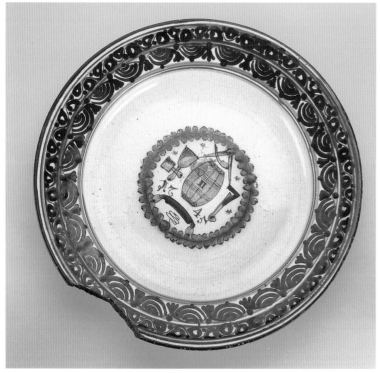

25

27
Clay shelf
EUROPE, 1729
Glazed earthenware

27

28
Norwegian bridal crown
NORWAY, C. 1750
Silver, precious stones, fabric

29
Swedish costume
(jacket and skirt)
FLODA, DALARNA, SWEDEN,
20TH CENTURY
Wool, cotton, fabric

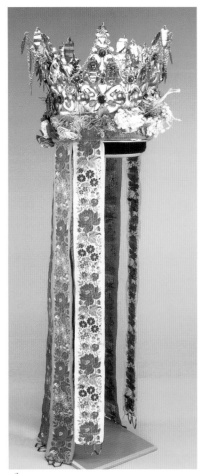

28

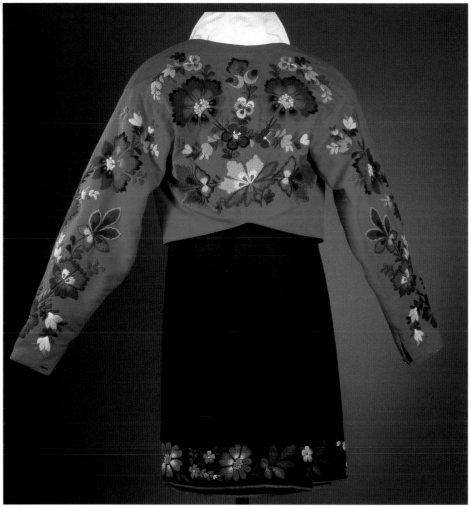

29

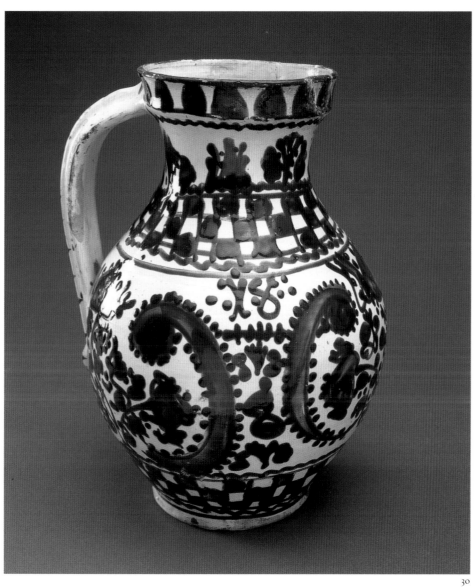

Ceramic pitcher
HUNGARY, 1818
Glazed earthenware

30

31
Bonader *painting*
SWEDEN, 1851
Mats Anders Olsson
Watercolor on paper

"In Ninevah, the Large City
He Gave the Word as Johah Had."

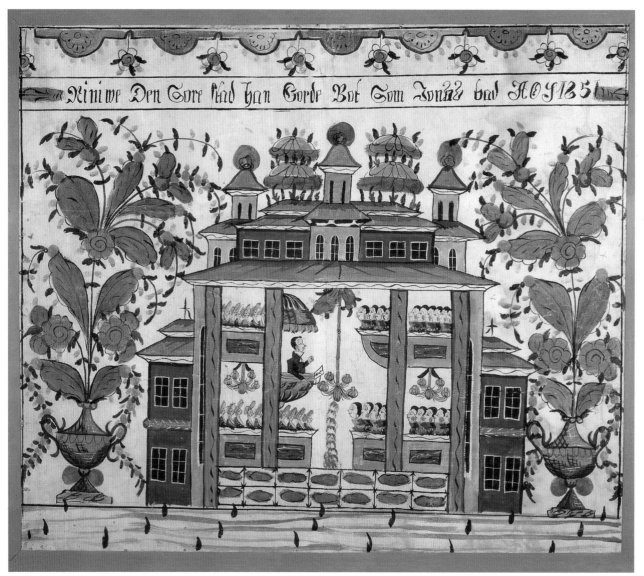

31

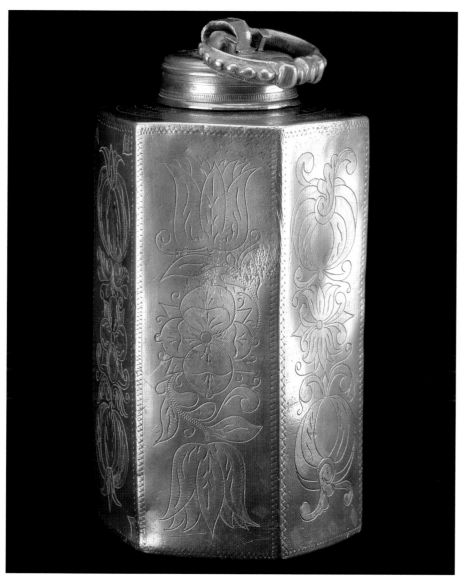

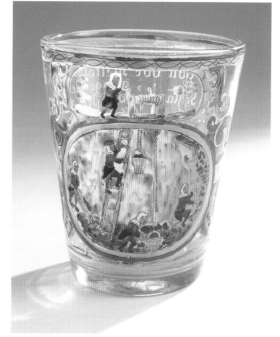

32
Wine flask
GERMANY, 1726
Pewter
GIFT OF MAIE BARTLETT HEARD,
THE HEARD FOUNDATION

33
Wedding glass
GERMANY, 18TH CENTURY
Painted glass
GIFT OF MAIE BARTLETT HEARD,
THE HEARD FOUNDATION

32

33

34
Plate

CENTRAL EUROPE, 1615

Pewter

GIFT OF MAIE BARTLETT HEARD,
THE HEARD FOUNDATION

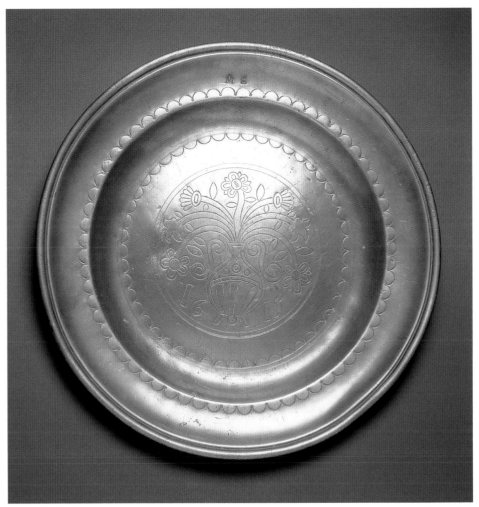

34

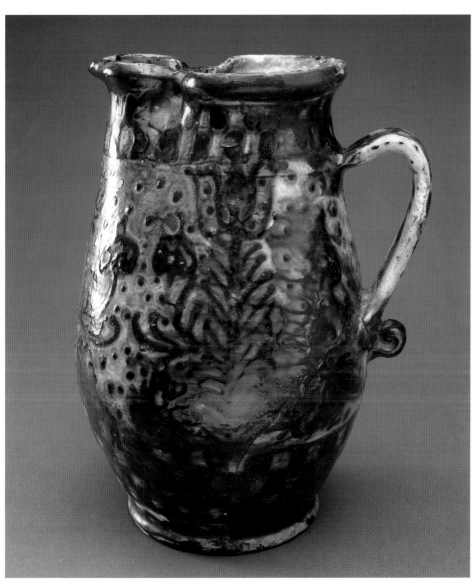

35
Ceramic pitcher
CENTRAL EUROPE, N.D.
Glazed earthenware
GIFT OF MAIE BARTLETT HEARD,
THE HEARD FOUNDATION

36
Necklace
YEMEN, C. 1900–1950
Silver, coral
L. 12 1/2 in.
A GIFT OF FLORENCE DIBELL
BARTLETT

BOBBIE SUMBERG
Curator of Textiles and Costumes

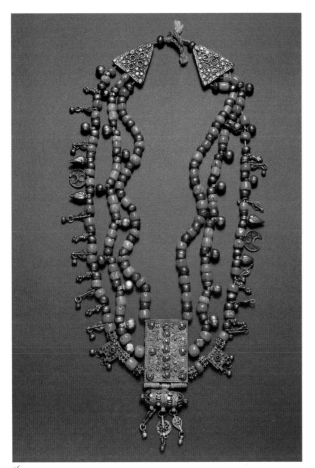

36

Sᴵʟᴠᴇʀ ᴊᴇᴡᴇʟʀʏ has been made and used in the Middle East for centuries. These Yemeni pieces incorporate both filigree and granulation, techniques that were already highly developed in the region by the ninth century.

The necklace, purchased by Florence Bartlett before 1953, is a classic piece of Yemeni jewelry. Coral and silver beads along with tiny pendants flank the central amulet box. This box is decorated with twisted-wire filigree forming a series of triangles that end in spirals. Small disks seemingly made of a series of tiny rings and a central bead run down the center and sides. The box is outlined on four sides by a granulated border. The cylindrical amulet box and many of the small pendants feature open filigree work as well.

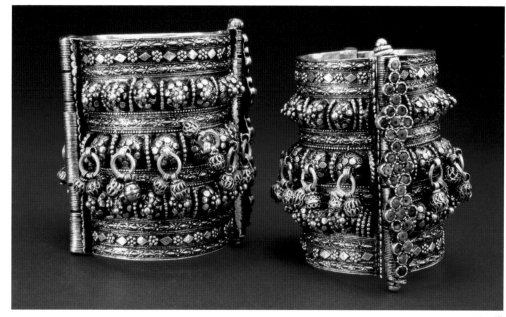

37

The bracelets, a recent purchase by the museum, are finely wrought examples of the silversmith's art. Wire filigree, granulation, and applied disks and diamonds fully cover the silver-sheet base. Small filigree beads dangle from the center row of raised hemispheres. Coral beads are set on the outside of the screw latch. Stamped inside by their maker, these bracelets were fashioned by a Jewish silversmith in Yemen before 1948, as was the necklace.

In its most visible and obvious use, jewelry adorns the body and enhances the wearer's appearance. But jewelry has other, equally important functions in many parts of the world. Coral, because of its red color, is considered powerful, and its use in jewelry ensures protection for the wearer. Amulet boxes that hold a verse of the Koran written on paper also protect the wearer from harm. A woman's ornaments display her status and are an investment. If a woman buys jewelry when she has some extra cash, she can always sell it when times are lean. Thus a pair of bracelets and a necklace represent not only a people's aesthetic but also aspects of their history, culture, economics, and religious belief. ▨

38
Moroccan amulet
MOROCCO, 19TH CENTURY
Gold, enamel, green and red stones

39
Moroccan anklets
MOROCCO, 19TH CENTURY
Silver, brass

40
Moroccan necklace
MOROCCO, 19TH CENTURY
Gold

38

39

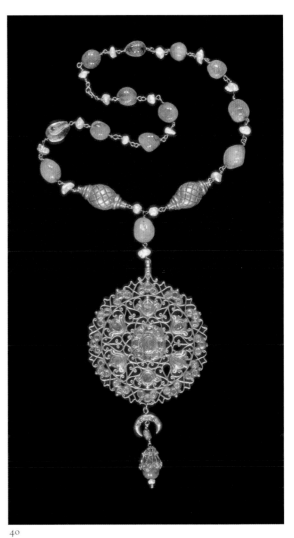

40

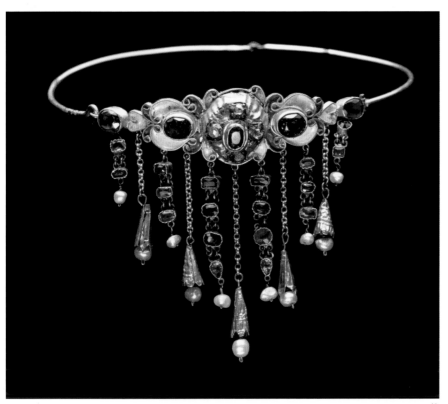

41

42

43

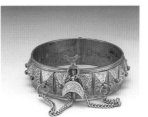

44

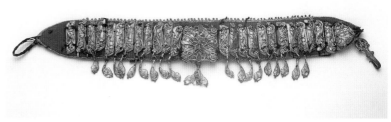

45

41
Moroccan necklace
MOROCCO, N.D.
Gold over silver, various stones

42
Moroccan necklace
MOROCCO, 19TH CENTURY
*Silver gilt beads, coral beads,
green and red stones*

43
Moroccan bracelet
MOROCCO, 19TH CENTURY
Gold, silver, enamel

44
Moroccan bracelet
MOROCCO, 19TH CENTURY
Silver gilt, gold

45
Moroccan headband
MOROCCO, 19TH CENTURY
Gold filagree, enamel on fabric, gold braid

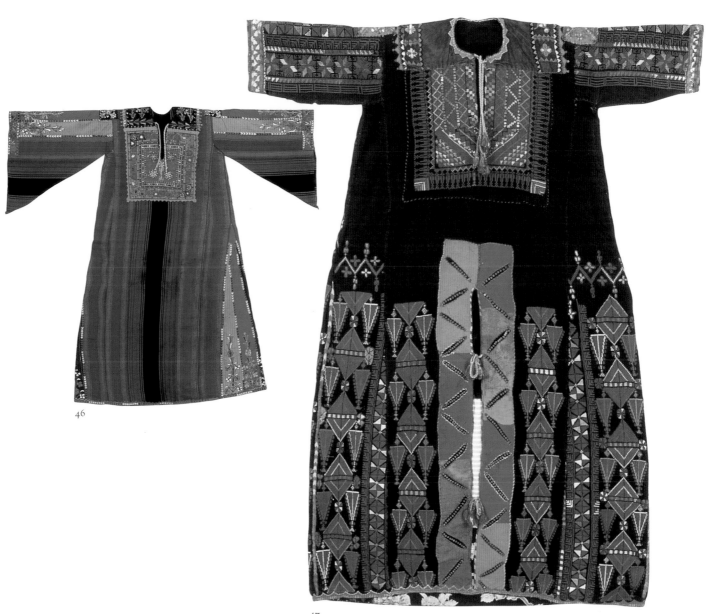

46
Palestinian dress
BETHLEHEM, LATE 19TH CENTURY
Indigo linen, silk, gold thread

47
Palestinian dress
BEIT DAJAN AREA,
CENTRAL COAST PLAIN, C. 1880
Indigo linen, silk, sequins

46

47

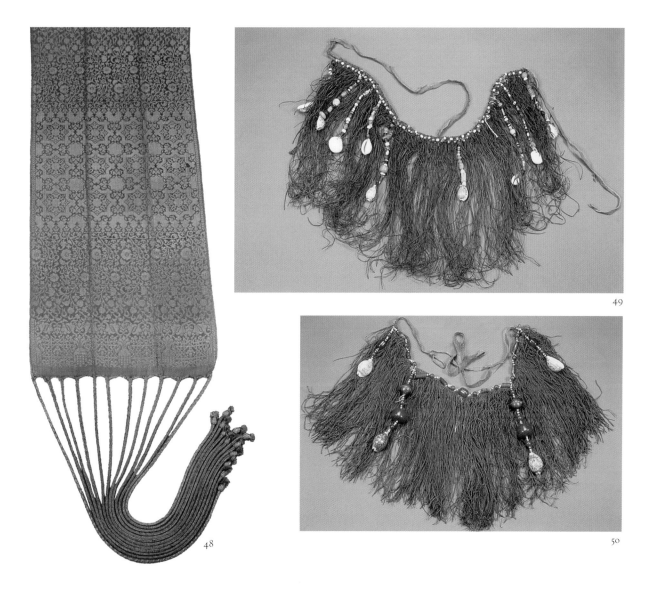

48

49

50

48
Wedding belt
MOROCCO, C. 1830
Silk, gold thread

49
Apron
SUDAN, C. 1920
Leather, glass beads, shells

50
Apron
SUDAN, C. 1920
*Leather, glass beads, amber beads,
silver beads, shells*

51
Chest
OLINALÁ, GUERRERO, MEXICO
MID-19TH CENTURY
Lacquered and painted wood
H. 14 in. (closed) × W. 32 ¹/2 in.
A GIFT OF FLORENCE DIBELL
BARTLETT

BARBARA MAULDIN
Curator of Latin American Collections

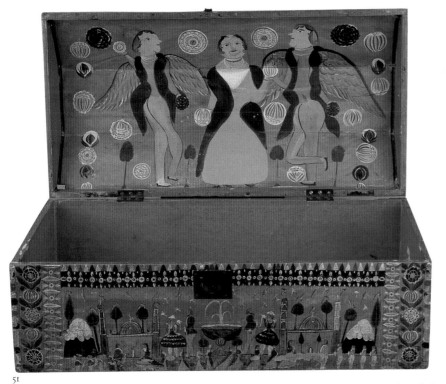

51

MEXICAN LACQUERWARE draws from pre-Hispanic, European, and Chinese craft traditions that came together in colonial Mexico and evolved into the colorful art form we know today. The lacquer technique involves applying and burnishing layers of oil, limy powders, and pigments onto a wood surface or gourds. The result is a hard, glossy finish on which artists paint fanciful motifs and pictorial scenes.

One of the production centers for Mexican lacquerware is the rural town of Olinalá, Guerrero, where indigenous artists have long used the technique to decorate a variety of forms, including large trunks that serve as bridal or dowry chests. Traditionally, the artists in Olinalá preferred a deep orange-red lacquered base on which they painted loose floral motifs and whimsical pictorial scenes. The painting on the front panel of this chest is a wonderful example of the naïve style used to portray idealized scenes of urban life. The dancing trio depicted on the lid interior is an interpretation of European aristocratic clothing and activities, as viewed by the natives.

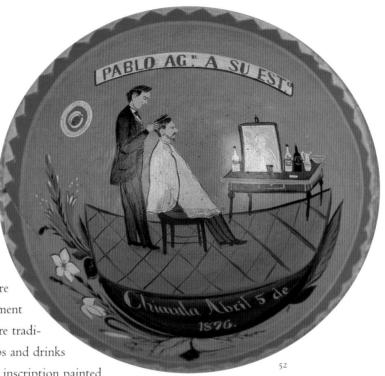

52
Bowl
OLINALÁ, GUERRERO, MEXICO , 1876
Lacquered and painted gourd
H. 2 ³/₄ in.; D. 4 ¹/₄ in.
A GIFT OF THE GIRARD
FOUNDATION

52

This is another example of nineteenth-century lacquerware from Olinalá, where the artist used the deep orange-red pigment to cover the surface of a circular gourd. Bowls such as this are traditionally used as drinking vessels in homes or for serving soups and drinks by food vendors in the marketplace. The pictorial scene and inscription painted on this bowl are unusual for a drinking vessel, however; the decoration suggests that someone commissioned the gourd as a commemorative piece to be hung on a wall or placed on a desk. As indicated in the top inscription, the patron may have been "Pablo AG," who wanted to be shown at his station (*a su est[ación]*) in his barbershop. The inscription underneath the scene—*Chiautla April 5 de 1876*—probably names the town where his business was located and a special date, perhaps the day it opened. As with the painting on the chest, the artist worked in a naïve style, portraying an aristocratic barbershop from an urban center, rather than the type of establishment and clothing that would be found in a rural village like Olinalá, Guerrero.

Wedding necklace
WESTERN HIGHLAND REGION,
GUATEMALA, C. 1900
Silver, glass, coral
L. 78 in.
A GIFT OF FLORENCE DIBELL
BARTLETT

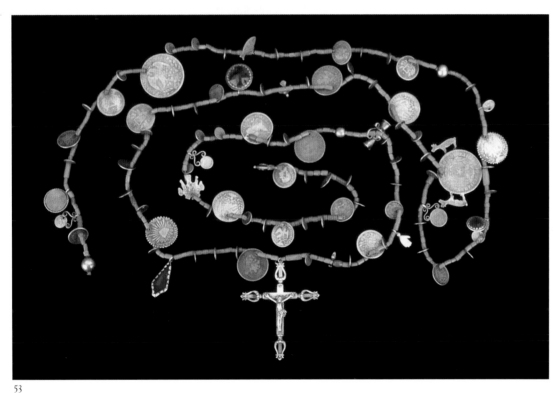

53

Indian women throughout Latin America adorn themselves with beautiful jewelry, primarily fashioned from silver and sometimes ornamented with coral and glass beads. The forms and style of the jewelry vary from one geographic/cultural region to another, and they often reflect pre-Hispanic traditions that were influenced by technology, materials, and ornaments introduced by the Spanish from the sixteenth through the eighteenth centuries.

Necklaces are a particularly important form of women's adornment in the Indian communities of Mexico and Guatemala, where older silver coins, beads, and amulets are often strung with coral or glass beads from Europe. This piece is made up of a long strand of coral beads interspersed with silver coins and amulets. The strand is wound around the necks of the bride and groom during their wedding ceremony.

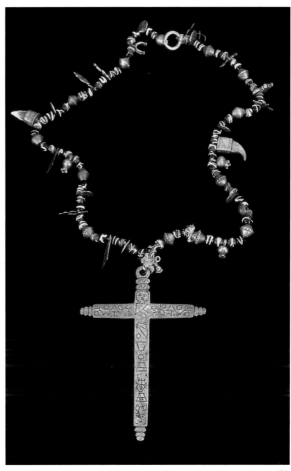

54
Necklace
CHOAPAN, OAXACA, MEXICO
19TH CENTURY
Silver, glass
L. 16 in.
IFAF; PURCHASED FROM
THE DONALD CORDRY COLLECTION

Indian villages in the Sierra Juarez region of Oaxaca, Mexico, were once known for their necklaces that featured crosses hung from the center in the style of Catholic rosaries. Those from the town of Choapan were characterized by a single cross ornamented with engraved motifs, such as the symbols of Christ's Passion in this example. The multicolored glass beads were produced in Italy in the eighteenth century and brought into Mexico by European merchants and colonists. Eventually they found their way into rural Indian communities such as Choapan, where they became prized possessions and were handed down from one generation to the next. The women were allowed to restring them and add other precious items, such as the silver amulets and animal claws seen here. ▨

54

55
Earrings
PATSCUARO, MEXICO
(TARASCAN PEOPLE),
EARLY 20TH CENTURY
Silver

56
*Guatemalan
wedding necklace*
GUATEMALA, C. 1900
Silver, coins, glass beads, silver beads

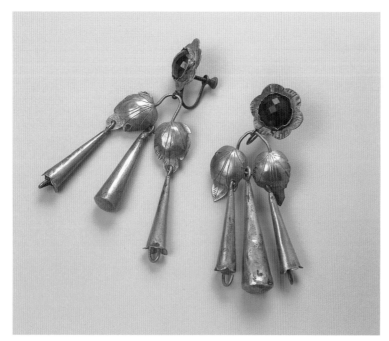

55

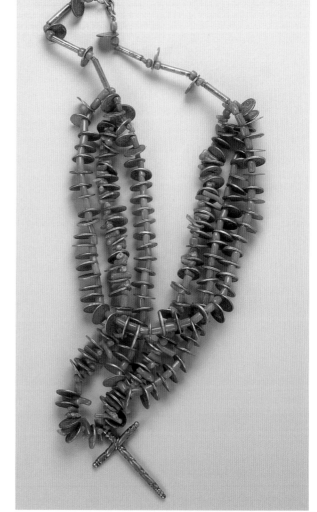

56

74

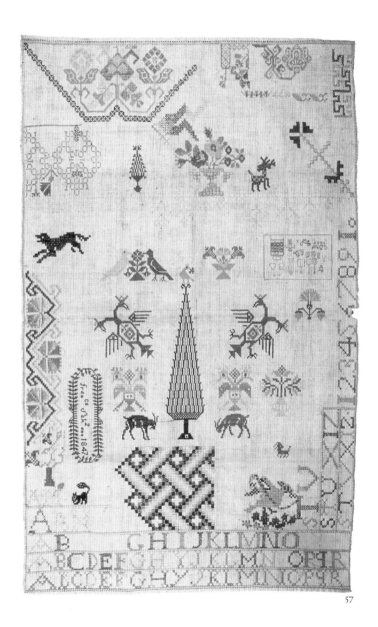

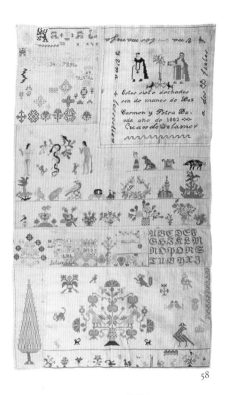

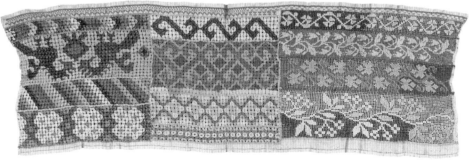

59

57
Embroidered sampler
MEXICO, 1847
Cotton

58
Sampler
MEXICO, 19TH CENTURY
Cotton

59
Sampler
MEXICO, 1862
Cotton

Mexican textile

MEXICO STATE, LATE 19TH CENTURY

Cotton

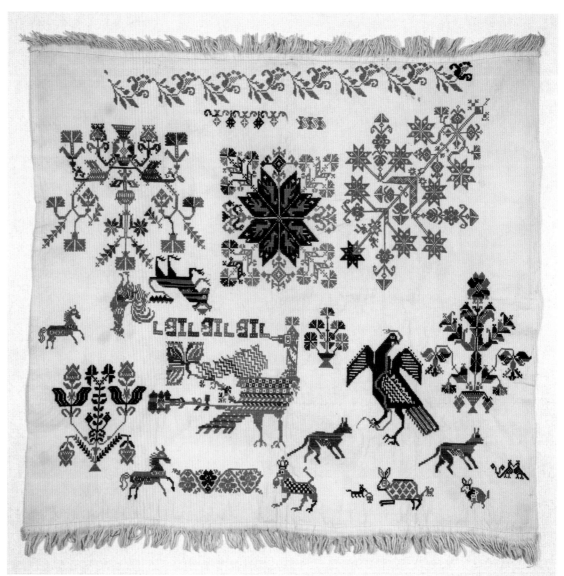

60

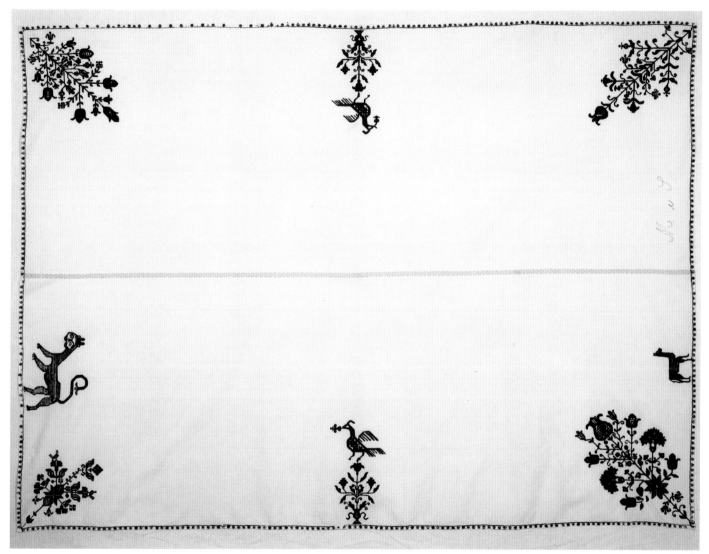

Mexican textile
TOLUCA, MEXICO, 19TH CENTURY
Cotton, wool

61

Polychrome jar
MEXICO, C. 1000
Clay

62

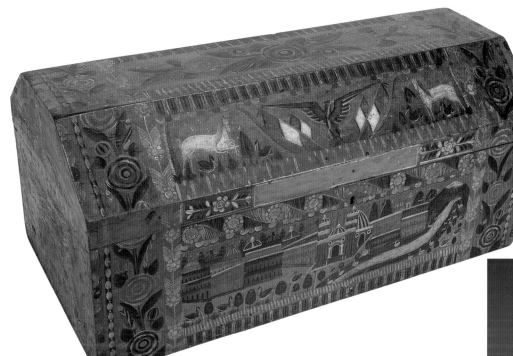

63

63
Mexican chest
OLINALÁ, GUERRERO, MEXICO,
MID-19TH CENTURY
Lacquered and painted wood

64
Bowl with lid
URAPAN, MICHOACÁN,
MEXICO (TARASCAN PEOPLE),
EARLY 19TH CENTURY
Lacquered and painted wood

64

65
Peacock pin
PERU (QUECHUA PEOPLE),
EARLY 20TH CENTURY
Silver

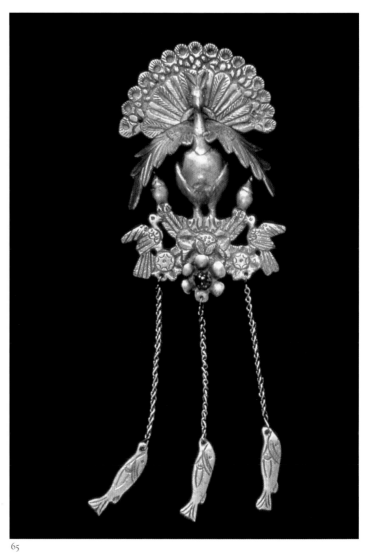

65

66

66
Bowl
URAPAN, MICHOACÁN,
MEXICO (TARASCAN PEOPLE),
EARLY 19TH CENTURY
Lacquered and painted wood

67
Basin
PUEBLA, MEXICO
1780–1825
Tin-glazed earthenware
D. 22 7/10 in.
HOUGHTON SAWYER COLLECTION;
GIFT OF MR. AND MRS. JOHN F.
HOLSTIUS

ROBIN FARWELL GAVIN
Curator of Spanish Colonial Collections

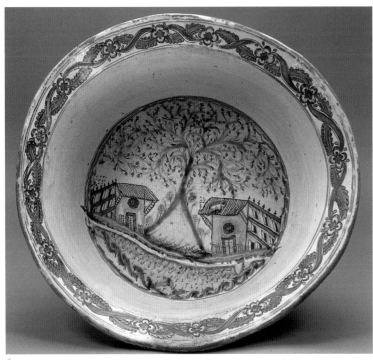

67

Puebla, Mexico, has been renowned as a ceramic production center since the mid-sixteenth century. At that time, Spanish-trained potters introduced the technique of tin enameling on earthenware along with the tools needed to produce it: the potter's wheel and the closed kiln. This pottery was soon very much in demand throughout the Americas. Referred to in historic documents as *loza de Puebla* or *talavera poblana*, it is most recognized for its distinctive blue-and-white style based on Chinese porcelains.

Throughout the history of tin-glazed pottery (majolica) in both Spain and Mexico, two different grades of pottery were produced: *loza fina* (fine ware) and *loza común* (common ware). These two pieces illustrate both grades in a single style known as *malva y verde* (mauve and green). The plate, collected by Bartlett, is in the neoclassical style popular throughout Europe and the Americas in the late eighteenth and early nineteenth centuries. It shows a bishop's miter and crozier painted in a reserved design with precise, fine lines and encircling bands with a chain motif. It was probably used on special occasions or as a commemorative platter.

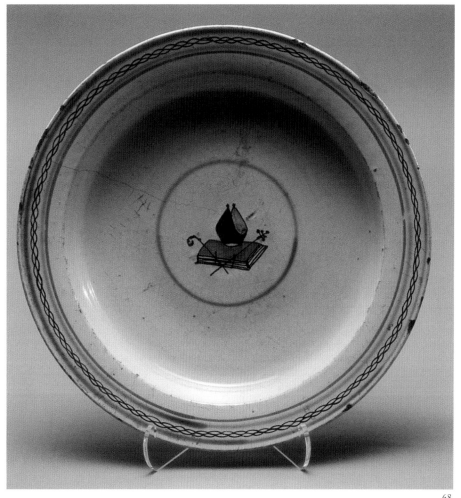

68
Plate with bishop's miter and crozier
PUEBLA, MEXICO, 1780–1825
Tin-glazed earthenware
D. 13 4/5 in.
A GIFT OF FLORENCE DIBELL
BARTLETT R COLLECTION; GIFT OF
MR. AND MRS. JOHN F. HOLSTIUS

68

The basin reflects the everyday use of these ceramics, anything from washing dishes to holding rising bread. Such *lebrillos* were found in many kitchens in Spain and Mexico. The decoration, also in the *malva y verde* style, illustrates a much more popular rendition of it, with stylized architectural features and a flowering tree enveloping the buildings. The painting lacks precision, with freer brush strokes and looser design, which sets it apart from the platter. A crack across the base went unheeded and was incorporated into the design. The encircling bands and chain along the rim, however, acknowledge the prevalent neoclassical style and help date the piece.

69
Clay jar
MEXICO, N.D.
Glazed earthenware

70
*Retablo of St. Michael
the Archangel*
NEW MEXICO,
EARLY 19TH CENTURY
Anonymous, possibly School
of Pedro Antonio Fresquis
(1749–1831)
*Gesso, water-soluble pigments
on hand-adzed pine panel*

69

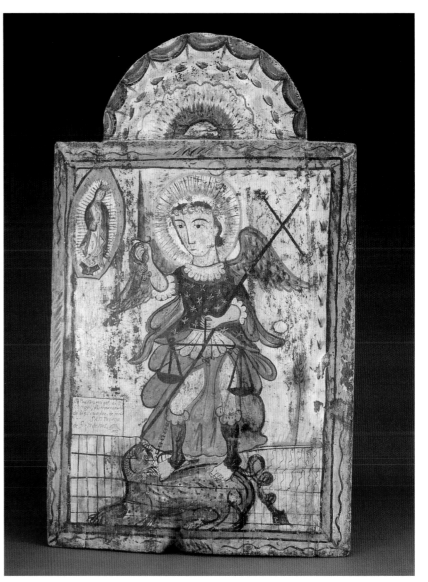

70

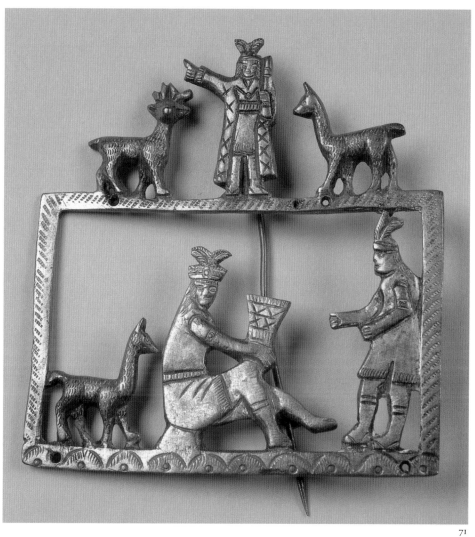

Pin with llama
PERU, 19TH CENTURY
Silver

71

TEY MARIANNA NUNN
*Curator of Contemporary Hispano and
Latino Collections*

Bartlett's collecting years predated the museum's contemporary Hispano and Latino collections. However, she contributed greatly to the museum's holdings and the cultural patrimony of northern New Mexico by collecting pre-twentieth-century examples of Hispanic art. These objects created from regional culture and tradition not only are historical and important in their own right, they provide a basis for innovation and creativity for contemporary artists. This is another one of Bartlett's legacies.

Florence Bartlett collected this example of colcha embroidery early in the twentieth century, at a time when few recognized the intrinsic artistic value of this type of handwork. The term *colcha* comes from *colchón*, the Spanish word for mattress; in New Mexico this type of work historically was used as a bedcovering. The colcha stitch was traditionally applied to a handwoven background cloth called *sabanilla*, and examples of this type of wool-on-wool work are referred to as *sabanilla labrada*. Many experts believe it to be distinctive to colonial New Mexico (Archuleta-Sagel 1996: 144–163).

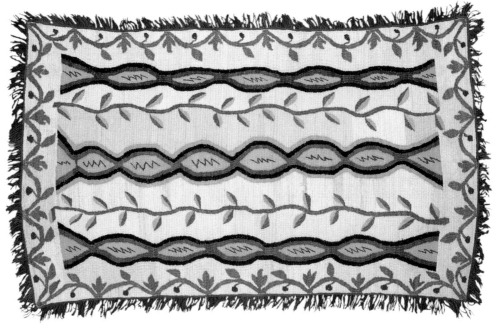

72
Colcha
UPPER RIO GRANDE VALLEY
PRE-1860
Wool, natural dyes
57 ¹/₂ in. × 35 ¹/₂ in.
A GIFT OF FLORENCE DIBELL
BARTLETT

72

In this work, green vines frame the piece with a border of leaves and red berries. Three undulating bands of brown, indigo, and yellow with red zigzag centers comprise the interior body of design. The center band is outlined in peach to offset the leaves of the same color. Since the piece also has handmade fringe, it may date to before 1860 (see Fisher 1994: 119–131; Macaulay 2000). The nature of this colcha is intriguing because it does not contain "typical" colcha elements such as birds and animals.

During the twentieth century, colcha embroidery moved from purely utilitarian use in households to narrative and decorative art to be admired and displayed. Until recently, this important transformation had only been studied sporadically. Thanks to Bartlett's foresight, the museum has an important collection of early colcha works that will help not only to preserve this artistic tradition but also to further its study and perhaps recover the names of the artists.

Colcha stitch cross
Emilio and Senaida Romero
SANTA FE, NEW MEXICO, 1986
Commercial yarn, cloth, tin, brass, glass
14 ¹/₂ in. ✕ 23 in.

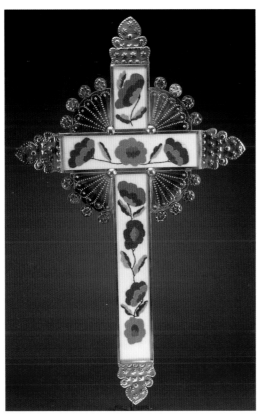

73

Santa Fe master tinsmiths Emilio and Senaida Romero spent most of their lives as artists, creating and collaborating throughout their long marriage. Emilio was a sheet-metal worker in Los Alamos when he started applying his skills to tin work in the traditional New Mexican style. He often worked at the kitchen table, and Senaida would help him design and create a variety of works, including boxes, lamps, lighting fixtures, mirrors, frames, and other decorative pieces. Senaida also excelled at colcha embroidery and, according to Romero, was the first artist to combine textile arts with tin at the Spanish Market in the 1970s, thus creating new and original designs for wall decorations and religious objects.

In 1988, the International Folk Art Foundation purchased one of their designs, a colcha stitch cross, for the museum's permanent collections. It was an important acquisition because of the increasing national attention given the Romeros. In 1987, they were named National Heritage Fellows for their collaboration on a work that combined tin and colcha embroidery, and in 1988, the Spanish Colonial Arts Society in Santa Fe gave them its Lifetime Achievement Award.

The artistry of the cross stands out in detail and execution. The colors of the exquisitely stitched traditional floral patterns mirror the larger, historic, and more geometric fringed colcha in subtle but important ways. In contrast to the larger wool-on-wool colcha, this work is indicative of post-1860 work resulting from the trading of cotton cloth and mass-produced or commercial dyes. Notice that the background cloth is not filled in completely as in the older bedcovering.

This tin and colcha cross exemplifies the innovation and originality of Hispanic New Mexican artists in the twentieth century that continues today. ▣

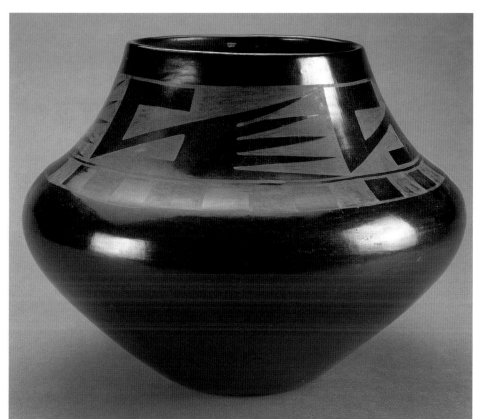

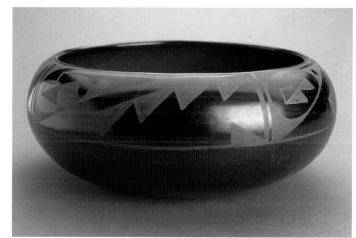

74
Pottery olla
NEW MEXICO, 1930S
Maria Martinez,
San Ildefonso Pueblo
Clay
(from El Mirador furnishings)

75
Pottery bowl
NEW MEXICO, 1930S
Maria Martinez,
San Ildefonso Pueblo
Clay
(from El Mirador furnishings)

74

75

76
Snuff bottle
CHINA, 1736–1795
Carved and molded porcelain,
silver, jade
3 1/4 in. × 2 1/4 in.
GIFT OF FLORENCE DIBELL
BARTLETT

TAMARA TJARDES
Curator of Asian Collections

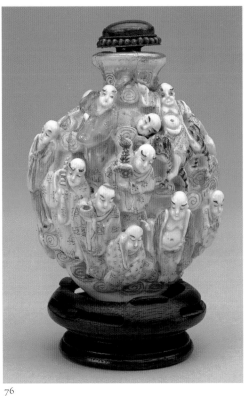

76

Luohan, or "worthies," were the personal disciples of the historical Buddha. Depicted as monks with shaven heads, they were regarded as patrons and guardians. As a group, luohan embody discipline; individually, they symbolize different stages or means of attaining enlightenment leading to nirvana—the extinction of the endless cycle of birth, suffering, death, and rebirth. These two pieces depict the luohan in vastly different artistic media.

The porcelain snuff bottle was produced during the reign of Ch'ien Lung, the fourth Manchu emperor of the Q'ing dynasty (1644–1911). During this time the ritual taking of snuff, or tobacco, was such a common practice that typically when friends met they at once exchanged snuff, and the containers that held it provided intellectual and artistic discussion. Because snuff bottles were also popular as gifts, demand and production were high. The beauty and symbolism of each bottle was of primary concern to the owner. The surface of this bottle contains the articulated personages of all eighteen luohan, and carrying it emphasized one's desire to emulate the Buddha's disciples.

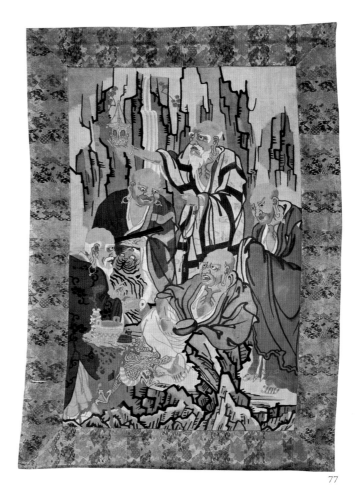

77
Hanging fragment
JAPAN, 1850–1910
Multicolored silk and gold-wrapped thread tapestry
84 1/4 in. × 60 1/8 in.
LLOYD COTSEN/NEUTROGENA
COLLECTION

77

The silk tapestry from Japan was possibly created to hang in the worship hall of a Buddhist monastery. It depicts three of the eighteen luohan. When Buddhism spread to Japan from China beginning in the sixth century, the Japanese adopted much of its established iconography. Here, Boloduoshe, with his tiger, exemplifies strength to overcome evil. Nantimiduolo Qingyu, with his begging bowl and incense vase, represents the rapidity of spiritual insight. Yinjieto holds a book illustrating the significance of scripture to enlightenment. The figures are worked in a bold tapestry technique called *kesi*, which was also introduced to Japan by Chinese crafts-men who had fled political unrest and the Manchu invasion that established the Q'ing dynasty. ▣

Indonesian head cloth

INDONESIA, N.D.

Gold leaf, batik

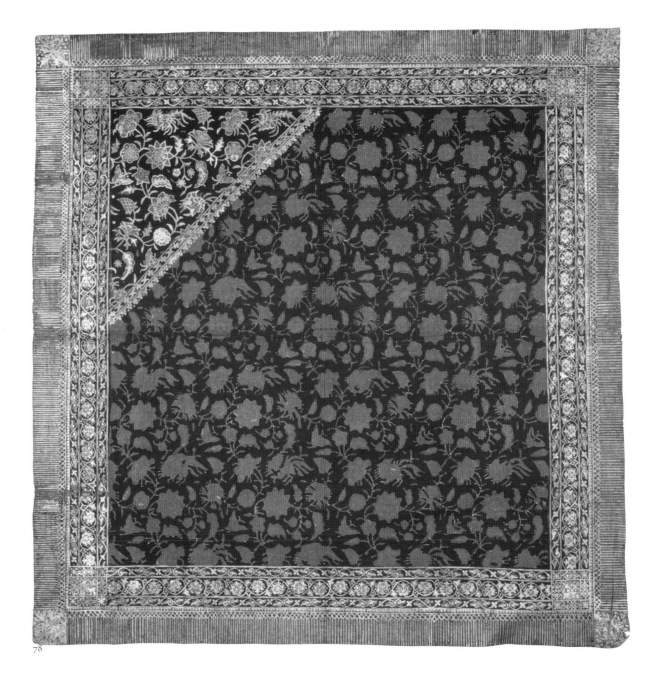

78

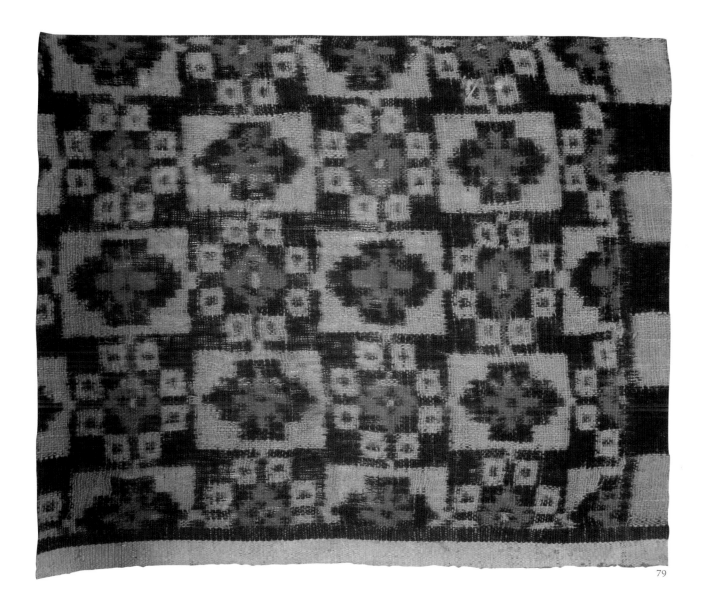

79
Ceremonial textile
INDONESIA, N.D.
Cotton

79

A World Center

Founding the Museum of International Folk Art

by Laurel Seth

"Y OU FEEL AT HOME" was the quote in *Pacific Life* magazine in 1957, four years after the opening of Florence Dibell Bartlett's visionary Museum of International Folk Art in Santa Fe—the first of its kind in the world. The quote is as appropriate today as almost five decades ago, and the museum's continuing popularity with visitors, as well as its respected place in the museum world, would please its founder. She hoped the museum would become a world center where the shared language conveyed by folk art could be understood by people everywhere.

Fifty years of acquisitions, exhibitions, programs, and publications have broadcast and built upon Florence Bartlett's original ideas when she gave the museum and her collection to the State of New Mexico in the late 1940s. She said: "I have made, during extensive travels over the globe, a folk art collection of old costumes, jewelry, textiles, ceramics, furniture and other objects which will become a nucleus for the Museum . . . where an appreciation of the culture and craft of other countries becomes a link in drawing the people into closer fellowship" (Bartlett 1953: 309).

She began collecting as a young woman and was still adding to her collection at the time of her death at seventy-three. She traveled the globe, sometimes with her sister Maie and her husband. They went to Egypt, Morocco, and the Sudan many times while Mr.

OPPOSITE:
The Museum of International Folk Art in 1953, south facade. The building was designed by John Gaw Meem in consultation with Florence Bartlett. Ahead of its time, its south side takes advantage of natural light and heat for lounge and office areas.
PHOTOGRAPH BY LAURA GILPIN, COURTESY: BARTLETT LIBRARY ARCHIVES, MOIFA/MNM

Heard investigated the cotton and palm trees he was to introduce to the Phoenix valley. Bartlett kept detailed records of her purchases, knowing, perhaps instinctively, what would be needed, in later museum records.

She was a discerning buyer, relying on trusted established shops, respected dealers, and museum experts, and most of all on her own eye. John Gaw Meem remembered her describing that it was the inherent beauty of an object that drew her most, and she hoped that this was the defining value and virtue of her collection (IFAF Records 1964).

Bartlett may have liked traveling to Scandinavia best, because the complete costumes she acquired there form one of the stronger areas of her collection, but her collection spans the world and almost every country and medium is well represented.

The journey from collecting important objects to building a museum oriented toward activity, education, and interaction is a complex trek, and Bartlett sought the advice of friends and experts to augment her concepts and bring this new place to life. In 1949, she named a formal advisory group of the persons she had consulted with her initial ideas. The official committee listed in the founding documents was composed of Bartlett; Rene d'Harnancourt, director of the Museum of Modern Art in New York; Frederic H. Douglas, curator of Native Arts at the Denver Art Museum; Miguel Jorrin, University of New Mexico; Daniel Catton Rich, director of the Art Institute of Chicago; Mrs. James Ward Thorne, Chicago; and Mitchell A. Wilder, director of presentations at colonial Williamsburg, Virginia.

At the same time, Bartlett engaged the services of John Gaw Meem, the preeminent architect in the Southwest, to build her museum. Originally, Meem was hired to consider converting El Mirador, her ranch in Alcalde north of Santa Fe, into a museum, but when that proved unfeasible, she asked him to design a modern building in Santa Fe on the hill adjacent to his classic Pueblo Revival-style Laboratory of Anthropology. The new Museum of International Folk Art was recognized as "the principal art museum building of the fifties so far" by the director of the American Association of Museums in the inaugural tribute publication (Bartlett 1953: 308–9).

Bartlett realized that her gift to the State of New Mexico's museum system was the largest it had ever received, and she wanted to augment it to assure an exceptional level of excellence in programs and exhibitions. To this end she established and endowed the International Folk Art Foundation (IFAF). Incorporated in 1951, with Bartlett as its first president, the foundation continues to be a separate, nonprofit organization that assists the museum in its mission and is a model of one of the first successful public/private partnerships in the museum world. The founding board consisted of people she knew and trusted would share her vision; they included Alice Howland, a Bryn Mawr graduate and the founder of Brownmor School in Tesuque; Dr. Boaz Long, director of the Museum of New Mexico and former U.S. ambassador to Guatemala; Ruth Laughlin, author of the popular southwestern novels *The Wind Leaves No Shadow* and *Caballeros*; John B. Jackson, renowned cultural and architectural historian; Y. A. Paloheimo, Finnish consul and international museum expert; and Dr. Robert Bruce Inverarity, director of the Museum of International Folk Art.

Crucial to the success of the new museum was the selection of its director, and Bartlett prevailed with her choice of Bruce Inverarity, an anthropologist and exhibition consultant who was hired in October 1949. Dr. Inverarity met with her to discuss the concept of the museum, and shortly after being hired he began traveling to museums

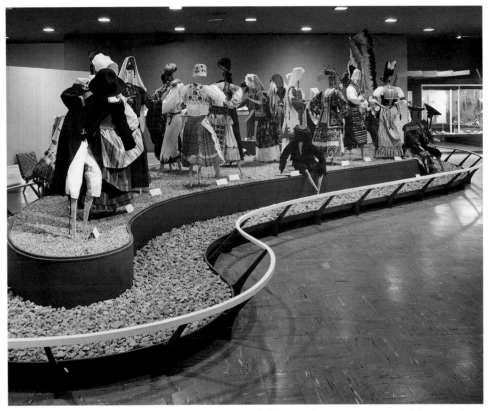

around the world for ideas, advice, and cautionary tales to examine with Bartlett, the advisory committee, and the architect.

Soon the road past the Laboratory of Anthropology two miles uphill from the Santa Fe plaza was busy with the traffic involved with constructing the state-of-the-art building. It had flexible grid ceilings in the exhibition rooms so that lighting could be specific for every exhibit and changed with ease; a modern fumigation chamber and conservation laboratory so that objects could be cared for with the newest technology; a large auditorium for programs, lectures, and films with adjoining dressing rooms, showers, and a wood-clad projection booth; the latest in shelving and storage areas; an elaborate alarm and emergency notification system; a spacious library with reading areas; and many more well-researched details.

The inaugural exhibition was similarly designed with attention to every detail of display. Dr. Inverarity commissioned abstracted human forms to showcase textiles and costumes from Bartlett's collection so that they would not distract from the objects themselves. These were arranged in a sort of international parade welcoming the visitors along a slightly raised platform, with only a low rail and no glass between the viewer and the art. The main concept of the opening exhibit was to evoke in the visitor

the knowledge that all peoples are basically akin to one another, even though costumes and everyday items used are almost infinitely varied in detail and form. To help illus-trate this, shoes from all over the world were placed around a large world map in the entryway with descriptions of their origins. Viewers fol-lowed footprints painted on the floors through the exhibit, where folk art from over sixty-three countries was displayed and folk music from around the world played through discretely placed speakers.

Interestingly, Bartlett herself may have pro-vided the inspiration for using shoes as a central metaphor for the exhibit. In her interview about the museum's opening with Edward R. Murrow in his famous radio program *This I Believe*, she recalled:

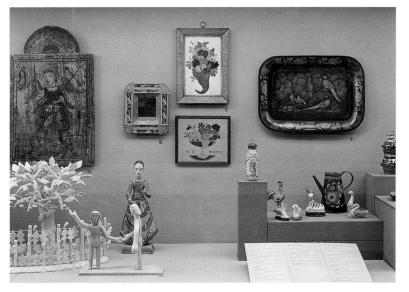

Items from Florence Dibell Bartlett's collection given to the State of New Mexico are displayed next to gifts from other individuals, museums, and countries in the inaugural exhibition in 1953. The variety of objects combined with the equality given in their display were to become museum hallmarks.
PHOTOGRAPH BY E. JOHANSON.
COURTESY: BARTLETT LIBRARY
ARCHIVES, MOIFA/MNM

Years ago from the backs of towering camels, our small party ambled over the vast Sahara Desert. An incident occurred on this caravan journey which led me to believe more deeply in the kinship existing between peoples of all nations. There among the silent sands unexpectedly we came upon an encampment of nomad Bedouins and soon we were surrounded by a group of barefooted women. With all friendliness, they examined and patted our shoes which were unknown objects to them. We, in turn, were impressed by their simple genuineness and warmth of feeling towards a strange people. So did a dark-skinned African tribe meet on a common ground with Americans from far away Chicago.

This common ground was one thing Bartlett sought to establish in her new museum, and this idea is echoed in the inscription over the entry. Originally painted by her friend, artist and puppeteer Gustave Baumann, she painstakingly crafted the words because she wanted them to convey as clearly as possible her hopes for the institution. The inscription reads: "The art of the craftsman is a bond between the peoples of the world," and for fifty years visitors have passed under it and entered a world where this bond becomes tangible in a multitude of ways.

Florence Bartlett was involved in almost every decision important to the museum, including planning the official opening ceremonies. Because this was a unique institution in the world and a monumental gift to the State of New Mexico, an enormous amount of preparation was required. The foundation printed thousands of free leaflets and distributed maps to the museum in local hotels and motels. The September 1953 issue of *El Palacio*, the Museum of New Mexico's magazine, was dedicated to it, as was a special multipage edition of the Santa Fe *New Mexican*, complete with congratulatory ads from local businesses. There were feature articles in national and regional magazines and newspapers, as well as a spot on the radio program *The Voice of America*, which was translated into twenty-seven languages, and Edward R. Murrow's interview with Bartlett, noted earlier.

The opening of the Museum of International Folk Art was big news, and anticipation was so high that Bartlett and the trustees and staff decided to hold a public open house in July prior to the official opening, so that locals and summer visitors could glimpse what was to come. Hundreds toured the facility, heard lectures on world travel, and drank tea in the auditorium in a preview of the formal opening.

By late summer 1953, the final touches were complete. Bartlett's collections were in safe storage or on display in the inaugural exhibit, along with important gifts from the French government, the Art Institute of Chicago, the Peabody Museum, the Heard Foundation, and many others interested in the success of the new museum. Engraved, hand-addressed invitations to the official opening were sent to over 275 foreign museum directors and diplomats, the directors of all major museums in the United States, United Nations officials, and many local officials and dignitaries, as well as hundreds of individuals.

So finally, during the brilliant autumn weekend of September 5–6, 1953, after many years of planning, collaboration, and hard work, Florence Bartlett cut the ceremonial ribbon, and to the strains of northern New Mexican *tipica* music, thousands of visitors walked under the inscription and began the tradition of visiting, enjoying, learning from, and loving the Museum of International Folk Art—a tradition that continues today.

THE FIRST FIFTY YEARS: A PLACE OF ACTIVITY

Every time another busload of children arrives on Museum Hill, as they have from the start, the Museum of International Folk Art again fulfills Bartlett's desire that it be a place of creative activity as well as for the exhibition of folk art. Each time scholars convene for a symposium about textiles or ceramics or Spanish Colonial art, her idea of bringing people together to form a fellowship of understanding is made manifest. When the world's folk music echoes in the foothills, it provides more ways to communicate and be understood. And each time a new treatise about *thanga* paintings from Tibet or jewelry from Palestine or majolica ceramics from Mexico is published, it proves again that art transcends boundaries and that Bartlett and the museum's staff, volunteers, and supporters have nurtured an important dream.

The Museum of International Folk Art's traveling exhibition van on the road in the 1950s with mini-exhibitions from the museum's collections. The van traveled throughout the state under the auspices of the International Folk Art Foundation from the 1950s until 1974, when the program was turned over to the Museum of New Mexico.

Describing five decades of exhibitions at the museum requires visualizing a world map with no boundaries, covered with many overlapping threads that lead to elaborate sidebars with titles, photographs, and textures. Other layers on this map would be needed to provide the sounds of folk music, the smells of exotic foods, and the exciting visual ideas contained in the myriad displays.

The inaugural exhibition that opened in September 1953 included costumes, jewelry, ceramics, furniture, and other objects from over sixty-three countries, arranged specifically to illustrate the differences and emphasize the likenesses among the peoples of the world. Florence Bartlett donated most of the pieces, but they were supplemented by gifts from other individuals, art institutions, and even governments. This exhibit exemplified the museum's underlying purpose and set the standard for each subsequent presentation.

Reading the titles of some of the exhibits from the 1950s is an evocative trip around the world: "When Cultures Meet"; "The Lion Dog in Chinese Popular Art"; "Folk Art of Japan"; "Decorative Arts of India"; "Craftsmen of New Mexico"; "San Blas Appliqué"; "Polish Paper Cutouts"; "The Word Is Shibui"; "One Europe"; "Photographs of Sarawak"; and "The Moslem World." These exhibits also reflected the growth of the museum's collections, and the programs, films, and lectures given in conjunction with them presented further opportunities for learning about the world.

In addition to exhibitions and programs in situ, a van was launched to carry smaller versions of the exhibitions to communities throughout New Mexico. Shortly after the museum opened, this large semitrailer truck was touring all the back roads of the state, one of the first such programs in the nation. These traveling tours continued from the 1950s until 1974, when the program was transferred to the entire Museum of New Mexico system.

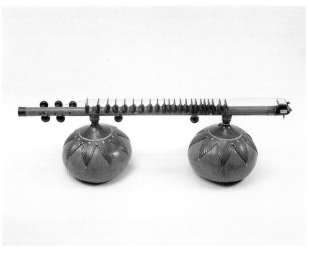

During the 1960s, visitors saw exhibitions and programs about art from Melanesia, Norway, Sweden, Tibet, Israel, Mexico, Greece, Thailand, Lapland, Japan, the U.S., Africa, China, Indonesia, Germany, and elsewhere. Craftspersons of New Mexico were also featured in yearly exhibits that displayed Rio Grande blankets, *santos*, colcha embroidery, and works by contemporary artists such as modernist Rebecca Salisbury James, Hopi jeweler Charles Loloma, Chimayo weaver David Ortega, and Taos santero Patrocino Barela. The popular folk singer Odetta performed in the auditorium. Richard Alpert, who later became the spiritual teacher Ram Das, gave his collection of musical

OPPOSITE:
The rug market in Istanbul in 1983. Dr. Henry Glassie undertook extensive fieldwork in Turkey sponsored by IFAF for the museum's exhibition "Turkish Traditional Art Today," for which he served as guest curator.
PHOTOGRAPH BY HENRY GLASSIE. COURTESY: BARTLETT LIBRARY ARCHIVES,MOIFA/MNM

instruments to the museum, and craftspeople from many nations came to demonstrate their work and visit the collections.

Twenty years after its founding, the museum hired its first female director, Dr. Yvonne Lange. During the 1970s, she continued to extend its basic commitment to showcase and interpret folk art from around the world. One of the museum's most popular exhibits—"What Is Folk Art?"—was mounted during that time. The collections continued to grow, with gifts of alpine folk art from Dr. Monroe Thornington, Asian textiles from Miss C. F. Bieber, Guatemalan textiles from the Shook family, and other important objects from many generous and knowledgeable donors.

The museum also supported making the documentary film *Dia de los Muertos,* about ceremonies in Mexico, by well-known American designers Charles Eames and Alexander Girard in the late 1950s, and the film *Any Woman Worth Her Salt* in 1988. Ethnomusicologist Richard Stark spent many years gathering, recording, and transcribing folk music in New Mexico, especially the *bailes* of the Hispanic community. A compact disc recording of northern New Mexico folk music compiled for the opening of the Hispanic Heritage Wing and the award-winning website of the exhibition, "Sin Nombre: Hispano and Hispana Artists of the WPA," are other examples of the museum's outreach to contact a wide audience.

Florence Bartlett often mentioned her concern that folk art should be preserved because the world was changing so fast, and with this in mind the museum inaugurated a series of collaborative workshops on New Mexico village embroidery. In 1974, one of the great successes was in Villanueva, New Mexico, where the village's own founding story was told in embroidery by local women of several generations. The tapestry has become a treasured focal point of the community and winds around all the walls of the local church.

In 1978, the museum received the extensive Girard Collection of folk art from around the world. Alexander and Susan Girard were inveterate collectors with an eye for color and

a flair for finding objects that evoked joy and delight. Girard, an internationally recognized designer, described his method of collecting by saying, "With me, it was really simple: love of the objects came first, and there was absolutely no other criterion for collecting" (Cerny 1982–3: 20). Their collection was unique in the world, and the museum, under Lange's inspired guidance, eventually persuaded the Girards that it would be the perfect home. The Girard Collection was the largest single gift since Bartlett's initial collection, and it expanded the museum's holdings fivefold.

The Girards traveled almost everywhere and, over more than fifty years, collected everything from toys to textiles. They emphasized the concept of displaying objects as part of whole vignettes about towns and festivals, in scenes depicted in miniature. There are stories that entire villages in Mexico became involved in making pieces for the collection, and whole families were supported in this endeavor.

The vast number of objects in the Girard gift—over 100,000 pieces from 100 countries—required an expansion of the museum to accommodate them. With an appropriation from the state and support from the International Folk Art Foundation and the Museum of New Mexico Foundation, the new Girard Wing was completed and opened in 1982. The Girards, like Florence Bartlett, shared a belief in the importance of folk art in understanding culture. Girard said, "My thought in this collection and exhibition is to present opportunities for connecting with people all over the world, while avoiding the bromide of 'one world'" (Cerny 1982–3: 20).

Today the Girard Wing exhibition, "Multiple Visions: A Common Bond," remains as Girard installed it twenty years ago, with color everywhere and folk art filling every conceivable space. Some objects hang from the ceiling, and some are visible only through windows low enough for small children to look through. There are no labels to distract one from seeing an object in its own context. Many scenes are re-created, from a Spanish bullfight with hundreds of ceramic figures to an elaborate, child-sized Christmas dinner with dolls and stuffed animals sitting in formal candlelight. One scene is of heaven and

OPPOSITE:
Artists from Turkey demonstrate their work and explore the area with local artists. Here Fatma Balci works on her traditional loom.
COURTESY: BARTLETT LIBRARY ARCHIVES, MOIFA/MNM

hell, with dozens of devils in their place and dozens of angels in theirs. A river of glass contains rows and rows of miniature boats from every nation that navigates the planet's waters. There is so much to see that visitors return again and again and still see something new each time.

The Hispanic Heritage Wing and Contemporary Gallery of Hispanic Art were the next major projects the museum built and installed, under the leadership of Lange's successor, Charlene Cerny. The collections have always been strong in Spanish Colonial art, with gifts from many local collectors, including Bartlett, her sister Maie Bartlett Heard, the John Gaw Meems, and from the Fred Harvey and IBM Corporation collections. The Archdiocese of New Mexico and, until recently, the Spanish Colonial Arts Society also loaned objects to be housed, conserved, and displayed. By 1988, another wing had been added to the original building to display these items of New Mexico history and culture.

When the Hispanic Heritage Wing opened, the occasion provided international publicity for the museum, with world leaders including the crown prince of Spain, the U.S. ambassador to Spain, and the Mexican consul in attendance, along with local artists, collectors, and museum supporters. The Hispanic Heritage Wing was the first permanent gallery in a U.S. museum dedicated to exhibiting traditional Hispanic arts, both colonial and contemporary. It has a more scholarly focus than the colorful Girard Wing, with extensive labels and interpretations and one of the first utilizations of touch-screen computer programming.

In 1989, Henry Glassie, a respected and much-published cultural anthropologist who was eager to do fieldwork in Turkey, was guest curator of the exhibit "Turkish Traditional Art Today," brought to fruition with the financial assistance of the International Folk Art Foundation. The foundation also helped fund the concurrent program "East Meets West," where Navajo weaver Pearl Sunrise, Hispanic weaver Irwin Trujillo, and father and

daughter weavers from Turkey, Ahmet and Fatma Balci spent weeks working together on different yet similar looms in a public display of creativity.

"Behind the Mask in Mexico," another exhibit from the late 1980s, was also the result of years of fieldwork. Researchers obtained entire costumes and sets of masks to supplement the museum's excellent collections, along with video and audio recordings of many regional dances. The costumes were displayed in groups, as they would be seen during a festival, and television sets near each group showed the videos so that visitors could see the larger context and actual use of the costumes.

The 1990s saw important variations on the traditional format of exhibitions and programs at the museum. "Mud, Mirror and Thread: Folk Traditions of Rural India," which opened in 1992, was a comprehensive examination of East Indian folk art, including textiles and jewelry. The museum even brought in Indian builders to re-create elaborate mud-plastered, mirror-studded walls in the exhibit area.

In the late 1980s and early 1990s, folk artists from the United States began to be honored as National Heritage Fellows by the National Endowment for the Arts. The museum saw an opportunity to amass a collection of these artists' works and to develop an exhibition and companion publication as well. The artists varied in background from Native Americans to recent refugees from Cambodia and Central America, and their occupations varied from musicians to lace makers to mask carvers. During the 1990 exhibit, the auditorium echoed with Cajun tunes, Native American chants, banjo riffs, gospel choirs, and old-time fiddle music.

In 1995, "All Tradition Is Change: An Exhibit of Swedish Folk Art" hearkened back to the inaugural exhibit and Bartlett's gift of Swedish costumes and *bonader* paintings. It also brought the region's folk art up to date at the museum, with new, modern weavings and woodwork. Craftspeople came to demonstrate bentwood box making, felt work, painting, and embroidery, and a farmer was imported to stack a special load of firewood

in the proper traditional manner for the exhibit. A parallel interactive exhibit for children was installed across the hall from the main exhibit. Groups could don Swedish caps or overalls, milk a wooden cow, which miraculously gave water through its rubber teats, gather wooden eggs, prepare a Swedish meal in the re-created wooden house, and even nap in the ingenious cabinet bed tucked into the side wall of the *Leskstugan*, a children's miniature farmhouse.

Curator Nora Fisher documented the folk art of Madhya Pradesh in preparation for the 1993 exhibition "Mud, Mirror and Thread: Folk Traditions of Rural India."
PHOTOGRAPH BY STEPHEN HUYLER. COURTESY: BARTLETT LIBRARY ARCHIVES, MOIFA/MNM

Florence Bartlett hoped that a group of international dwellings could eventually be brought to the museum site, so that people might see and experience different lifestyles in that larger context. Perhaps this idea was inspired by her visits to the 1893 Columbian Exposition as a child, where her first exposures to international art probably occurred. Her special affinity for Sweden was recognized during the Chicago World's Fair in 1933, when King Gustave V awarded an older and much more traveled Bartlett the Vasa Medal, a rare departure from the policy of giving it only to Swedish citizens. It was probably at this fair that she arranged to purchase a small Swedish house that was part of the display and send it to New Mexico, but the house did not survive transport. Many years later, the *Leskstugan* was re-created for a time at the museum and then donated to the Swedish American Museum in Chicago, where it continues to be a popular attraction.

Perhaps the most ambitious exhibition of recent times opened in 1996; it was called "Recycled, Re-seen: Folk Art from the Global Scrap Heap." This timely and timeless exhibition explored the realities of industrialization and the wastefulness of much of modern society by displaying objects made from recycled materials throughout the world. Objects

were gathered from field research in Africa, the Caribbean, India, the Middle East, Europe, and the United States. Antique jewelry made from recycled buttons or vinyl records was shown alongside quilts (a more familiar example of recycling) and memory boxes, figures made of aluminum pop-top cans, muffler men, and toys from every nation. There were fashion shows in the auditorium, where dresses dubbed "trashique" were modeled. Music was played on instruments made from gourds, plastic tubs, metal cans, and things that were hard to identify. The museum sponsored a show of automobiles decorated with coins, beans, toys, and other found objects. Children made masks from Styrofoam containers and bottle caps and jewelry from just about everything.

Another timely exhibit, which opened in 1998, displayed Tibetan art and was titled "At Home Away from Home: Tibetan Culture in Exile." The invitation and large photomurals at the entrance depicted the mountains of Tibet next to the Sangre de Cristo Mountains of Santa Fe, where there is a relatively large population of Tibetan refugees. The local Tibetan community became involved, and many family and community celebrations were held at the museum during the exhibit, indeed making it a home away from home.

In 1997, Lloyd Cotsen, founder of the Neutrogena Corporation and an avid and discerning collector of folk art, began looking for a home for his collection, which was housed at the time in the corporate offices in Los Angeles. Cotsen was familiar with the museum and its collections, exhibitions, and programs, as well as its mission to present the world's folk art so that people gain better understanding of one another. He decided, as Florence Bartlett once had, that New Mexico was the perfect place for his collection.

Jóse Ignacio Criollo poses at his home in San Rafael, Ecuador, with two dance headdresses that he made from found and recycled objects.
PHOTOGRAPH BY BARBARA MAULDIN

He offered the state a proposition also similar to Bartlett's: the collection would belong to New Mexico, he would pledge a sizable donation to the Museum of New Mexico Foundation to maintain and display it, and the state would, in turn, appropriate the majority of funds to build an addition to house and display the objects. Additional funds for construction and programs came from IFAF.

In the book on the collection, *The Extraordinary in the Ordinary*, Cotsen wrote, "People often ask me how I could amass such a Collection over the course of thirty-five years and then give it away. I do not think I am giving it away—instead I feel I am sharing it with more people." This is the philosophy that underlies the founding of the museum. Later, in an echo of Girard, he continued: "All of these objects have one thing in common; they strike some emotional bell within me; in short, they just appeal to me" (Kahlenberg 1998).

The Neutrogena Wing opened in 1998 with much celebration, and accolades in publications throughout the country. Cotsen's gift increased the museum's collections enormously in many important areas, particularly through the textiles he had gathered in his extensive travels. Because he felt that objects were best viewed as artworks on their own, without labels and interpretations, the first three exhibits in the new wing have followed his wishes. In the Cotsen Interactive Gallery, where objects can be touched and examined, small exhibitions change frequently, and visitors can learn about the process of museum curating by seeing the storage areas, experimenting with conservation techniques, and asking questions of curatorial assistants.

The Neutrogena Wing exhibits have been the main focus of the late 1990s and the beginning of this century. The exhibit space is large, flexible, and modeled in many ways after the original Bartlett area with its hanging grid ceiling and open floor plan. In the most recent exhibit of textiles there, modern amorphous forms draped in textiles greeted visitors in a parade reminiscent of the first exhibition in 1953.

In 1998, Dr. Joyce Ice was named director when Charlene Cerny retired. Her plans continue to honor Florence Bartlett's vision, as evidenced in the 2001 exhibit "Seldom Seen," which showcased outstanding collection pieces selected by four curators of the museum. Many objects were from the original Bartlett gift, some were recent acquisitions or gifts, but all exemplified the conviction that folk art is a common language that is easily understood and important to preserve and practice. Two additional recent, notable

A 2002 view of "Museum Hill" from the Museum of International Folk Art. The parking lot was moved downhill to create Milner Plaza, a new area for outdoor activities for the folk art museum and its neighboring Museum of Indian Arts and Culture.
PHOTOGRAPH BY FRANK X. CORDERO. COURTESY: BARTLETT LIBRARY ARCHIVES, MOIFA/MNM

exhibitions were "One Hundred Aspects of the Moon," an exhibit of Japanese woodcuts (2001), and "Dressing Up," a presentation of children's clothing from around the world, which opened in early 2002.

The original building has seen some recent refurbishing and expansion, particularly in the entryway, the 1950s lounge area—now an enclosed atrium—and the library. Museum Hill is newly landscaped, and a large exterior plaza covers the old parking lot. Future plans include a major exhibit of majolica pottery, "Ceramica y Cultura," from Spain, Morocco, France, and Mexico, complete with a model of a Spanish galleon, loaded

with ceramics and other trade goods that linked the world centuries ago yet reflect today's links as well. Also planned is an exhibit titled "Vernacular Visionaries," which will include paintings by so-called outsider artists. This exhibit will reinforce the fact MOIFA reflects a world with no boundaries and is a place that applies no definitions that would keep someone "outside" of the "home away from home" it provides for the collection and its visitors.

In this glimpse of the museum's activities of the past fifty years, it becomes clear that the fresh visions of five decades ago are still relevant and that Florence Bartlett's certainty that folk art expresses the bonds of understanding between the world's people is still true today.

Bibliography

PUBLISHED AND UNPUBLISHED SOURCES

Archuleta-Sagel, Teresa. 1996. "Textiles." In *Spanish New Mexico: The Spanish Colonial Arts Society Collection*, eds. Donna Pierce and Marta Weigle. Santa Fe: Museum of New Mexico Press.

Babb, Alma L., et al. 1963. *A Tribute to Florence Dibell Bartlett: Recollections by Some of Her Friends*. Santa Fe: International Folk Art Foundation.

Bancroft, Hubert Howe. 1895. *The Book of the Fair: World's Science, Art, and Industry, as Viewed Through the Columbian Exposition at Chicago in 1893*. Chicago: The Bancroft Company.

Bartlett, Florence D. 1953. "The Purpose of the Museum." *El Palacio* 60 (9): 308–9.

Bartlett, Frederic Clay. 1965. *Sortofakindofa Journal of My Own*. Chicago: Lakeside Press.

Bronner, Simon J., ed. 1989. *Consuming Visions: Accumulation and Display of Goods in America, 1880–1920*. New York: W. W. Norton and Company.

Burt, Nathaniel. 1977. *Palaces for the People: A Social History of the American Art Museum*. Boston: Little, Brown and Company.

Cerny, Charlene. 1982–3. "An Interview with Alexander Girard." *El Palacio* 88 (4): 20.

———, et al. 1995. *Folk Art from the Global Village: The Girard Collection at the Museum of International Folk Art*. Santa Fe: Museum of New Mexico Press.

Cerny, Charlene, and Suzanne Seriff. 1996. *Recycled, Re-seen: Folk Art from the Global Scrap Heap*. New York: Harry N. Abrams in assoc. with Museum of International Folk Art, Santa Fe.

Chauvenet, Beatrice. 1985. *John Gaw Meem: Pioneer in Historic Preservation*. Santa Fe: Historic Santa Fe Foundation/Museum of New Mexico Press.

Danly, Susan, ed. 2002. *The Morrow Collection of Mexican Popular Arts*. Published for the Mead Art Museum, Amherst College. Albuquerque: University of New Mexico Press.

Esser, Janet Brody, ed. 1988. *Behind the Mask in Mexico*. Santa Fe: Museum of New Mexico Press.

Fisher, Nora. 1992. *Mud, Mirror and Thread: Folk Traditions of Rural India*. Chidambaram, Ahmedabad, India: Mapin Publishing Pvt.

————. 1994. "Colcha Embroidery." In *Rio Grande Textiles*, ed. Nora Fisher, 119–131. Santa Fe: Museum of New Mexico Press.

————, ed. 1979. *Spanish Textile Tradition of New Mexico and Colorado*. Santa Fe: Museum of New Mexico Press.

Frueh, Erne R., and Florence Frueh. 1979. "Frederic Clay Bartlett: Chicago Painter and Patron of the Arts." *Chicago History: The Magazine of the Chicago Historical Society* 8 (1): 16–19.

Glassie, Henry. 1989. *The Spirit of Folk Art: The Girard Collection at the Museum of International Folk Art*. New York: Harry N. Abrams.

————. 1991. *Turkish Traditional Art Today*. Bloomington: University of Indiana Press.

Goodspeed, Thomas. 1925. *University of Chicago Biographical Sketches*. Vol. 2. Chicago: University of Chicago Press.

Harris, Neil. 1990. *Cultural Excursions: Marketing Appetites and Cultural Tastes in Modern America*. Chicago: University of Chicago Press.

Hein, Hilde S. 2000. *The Museum in Transition: A Philosophical Perspective*. Washington, D.C.: Smithsonian Institution Press.

Isabella Stewart Gardner Museum. 1997. *Cultural Leadership in America: Art Matronage and Patronage*. Volume 27 of Fenway Court. Boston: Isabella Stewart Gardner Museum.

Kahlenberg, Mary Hunt, ed. 1998. *The Extraordinary in the Ordinary: Textiles and Objects from the Collection of Lloyd Cotsen and the Neutrogena Corporation*. New York: Harry N. Abrams.

Kert, Bernice. 1993. *Abby Aldrich Rockefeller: The Woman in the Family*. New York: Random House.

Lurie, Allison. 1981. *The Language of Clothes*. New York: Henry Holt and Company.

Macaulay, Suzanne P. 2000. *Colcha Embroidery Along the Northern Rio Grande*. Tucson: University of Arizona Press.

Mather, Christine. 1983. *Colonial Frontiers: Art and Life in Spanish New Mexico*. Santa Fe: Ancient City Press.

Mayer, Harold M. 1969. *Chicago: Growth of a Metropolis*. Chicago: University of Chicago Press.

McCarthy, Kathleen D. 1991. *Women's Culture: American Philanthropy and Art, 1830–1930.* Chicago: University of Chicago Press.

Meeker, Arthur. 1949. *Prairie Avenue.* New York: Alfred A. Knopf.

Mullin, Molly H. 2001. *Culture in the Marketplace: Gender, Art, and Value in the American Southwest.* Durham, N.C.: Duke University Press.

The New Mexican. "La Duena," April 5, 1953; June 22, 1953; August 30, 1953, B2. Santa Fe: The *Santa Fe New Mexican.*

————. May 3, 1954, 2.

Niederman, Sharon. 1988. *A Quilt of Words: Women's Diaries, Letters & Original Accounts of Life in the Southwest, 1860–1960.* Boulder, Colo.: Johnson Books.

Novak, Barbara. 1969. *American Painting of the Nineteenth Century: Realism, Idealism, and the American Experience.* New York: Praeger Publishers.

Nunn, Tey Marianna. 2001. *Sin Nombre: Hispana and Hispano Artists of the New Deal Era.* Albuquerque: University of New Mexico Press.

Rudnick, Lois Palken. 1984. *Mabel Dodge Luhan: New Woman, New Worlds.* Albuquerque: University of New Mexico Press.

Ruegamer, Lana. 1982. "'The Paradise of Exceptional Women': Chicago Women Reformers, 1863–1893." Ph.D. diss., Indiana University.

Rydell, Robert W. 1984. *All the World's a Fair: Visions of Empire at American International Exhibitions, 1876–1916.* Chicago: University of Chicago Press.

Rydell, Robert, John E. Findling, and Kimberly D. Pelle. 2000. *Fair America: World's Fairs in the United States.* Washington, D.C.: Smithsonian Institution Press.

Sellars, Judith, et al. 1979. *Celebrate: The Story of the Museum of International Folk Art.* Santa Fe: Museum of New Mexico Press.

Siporin, Steve. 1992. *American Folk Masters: The National Heritage Fellows.* New York: Harry N. Abrams.

Solnit, Rebecca. 1996. "The Procession of Cowboys and Indians, or the Postmodern Old West." *Art Issues* 44, 45 (September and December).

Stark, Richard. 1969. *Music of the Spanish Folk Plays in New Mexico.* Santa Fe: Museum of New Mexico Press.

Stillman, Yedida Kalfon. 1979. *Palestinian Costume and Jewelry.* Albuquerque: University of New Mexico Press.

Tepfer, Diane. 1989. "Edith Gregor Halpert and the Downtown Gallery Downtown: 1926–1940: A Study in American Art Patronage." Ph.D. diss., University of Michigan.

Tharp, Louise Hall. 1984. *Mrs. Jack: A Biography of Isabella Stewart Gardner*. New York: Congdon and Weed.

Wheelwright, Mary Cabot. N.d. "Memoirs: Journey Towards Understanding." Santa Fe: Wheelwright Museum.

ARCHIVAL SOURCES

Archives of American Art, Smithsonian Institution, Washington, D.C.

Arizona State History Archives, Phoenix, AZ.

Art Institute of Chicago Archives, Chicago, IL.

Bartlett Library Archives, Museum of International Folk Art, Santa Fe, NM.

(CECA) Central Eleanor Club Archives, Eleanor Club Foundation, Chicago, IL.

Chicago Public Library, Chicago, IL.

Fray Angelico Chavez History Library Archives, Museum of New Mexico, Santa Fe, NM.

Heard Museum Photo Library/Archives, Phoenix, AZ.

(IFAF) International Folk Art Foundation Records, 1950, 1953, 1954, 1964, Museum of International Folk Art, Santa Fe, NM.

John Gaw Meem Archives, Zimmerman Library, University of New Mexico, Albuquerque, NM.

Newberry Library, Chicago, IL.

New Mexico State Records Center and Archives, Santa Fe, NM.

Photo Archives, Palace of the Governors, Museum of New Mexico, Santa Fe, NM.

Smith College Archives, Northampton, MA.

University of Chicago, Chicago, IL.

University of Illinois at Chicago, Chicago, IL.

NONBOOK MATERIALS

Edward R. Murrow. Interview with Florence Dibell Bartlett, *This I Believe* radio broadcast, 1953.

Authors' Interview with Ann Baumann, April 2002.